Dan Friedman: Radical Modernism

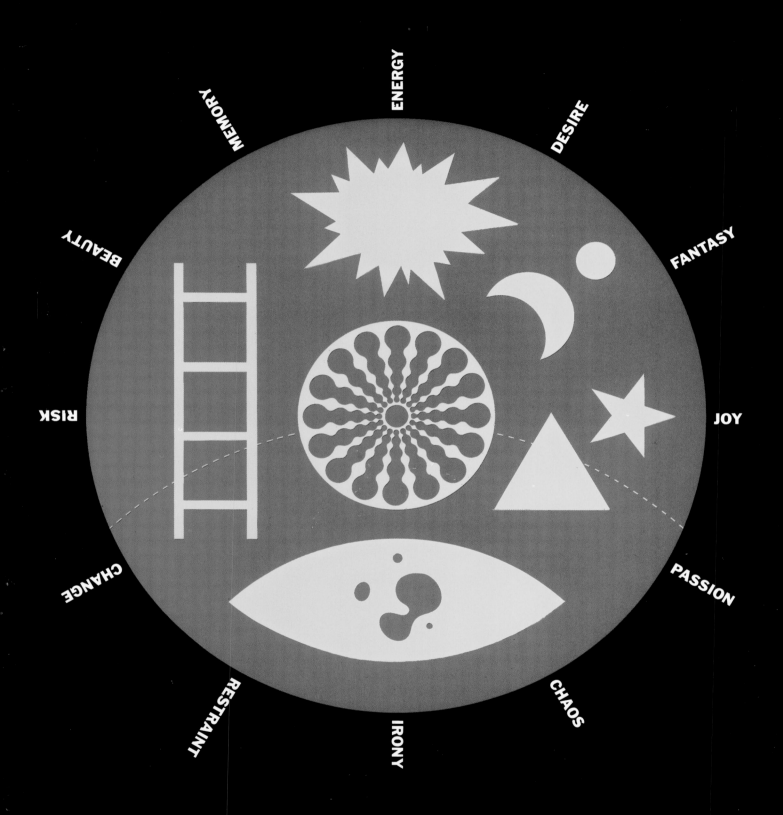

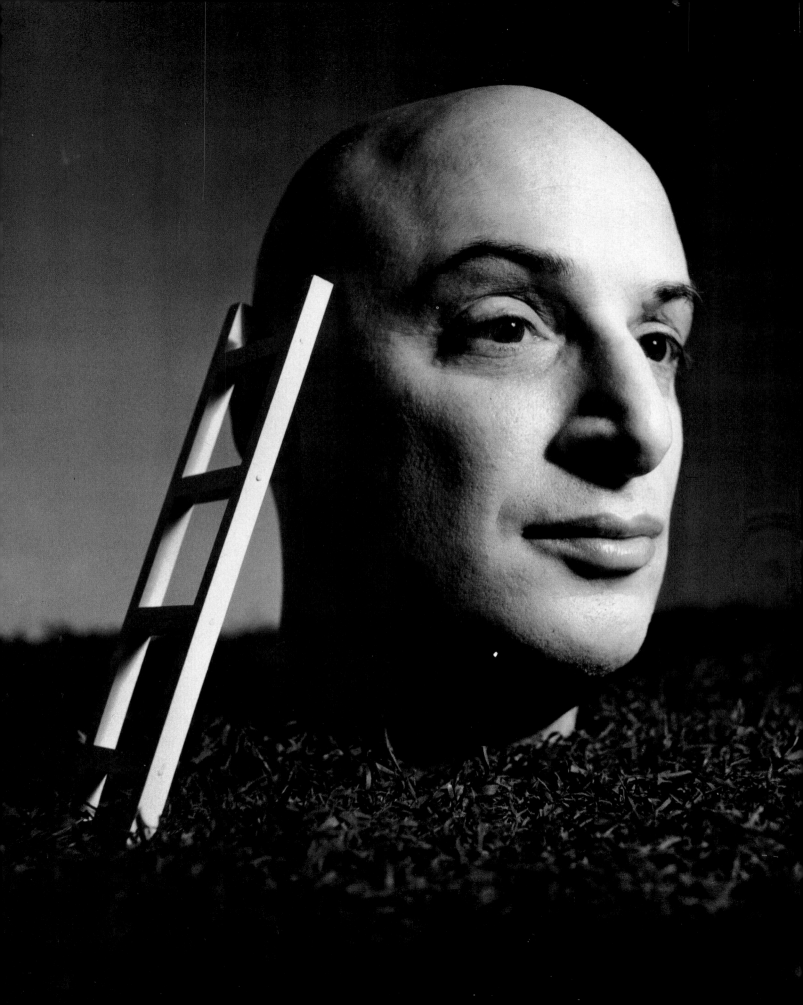

Dan Friedman: Radical Modernism

by Dan Friedman

With essays by
Jeffrey Deitch
Steven Holt
Alessandro Mendini

Yale University Press
New Haven and London

Published with assistance from the foundation
established in memory of Calvin Chapin of the Class of
1788, Yale College.

Steven Holt's essay "Model Revolutionary" is adapted
from "The Design World's Favorite Enigma," *Graphis* 275
(September-October 1991).

Design by Dan Friedman.
Set in Franklin Gothic and Univers 45 type by
New Age Typographers, Inc.
Printed in Italy by La Cromolito

Library of Congress Cataloging-in-Publication Data
Friedman, Dan
Dan Friedman: Radical Modernism by Dan Friedman;
essays by Jeffrey Deitch, Steven Holt,
Alessandro Mendini.

ISBN 0-300-05848-9
ISBN 0-300-05849-7 (pbk.)
1. Design — History — 20th century.
2. Modernism (Art)
I. Deitch, Jeffrey. II. Holt, Steven, 1957— .
III. Mendini, Alessandro, 1931— . IV. Title
NK1390.F75 1994
709 . 04 — dc20
93-21035 CIP

A catalogue record for this book is available from the
British Library. The paper in this book meets the
guidelines for permanence and durability of the
Committee on Production Guidelines for Book Longevity
of the Council on Library Resources.

10 9 8 7 6 5 4 3 2 1

Contents

We live in
an increasingly
changing world; the result
is that we have become so dizzy
that we have lost a sense of the roots
and the new possibilities
of our modernity.

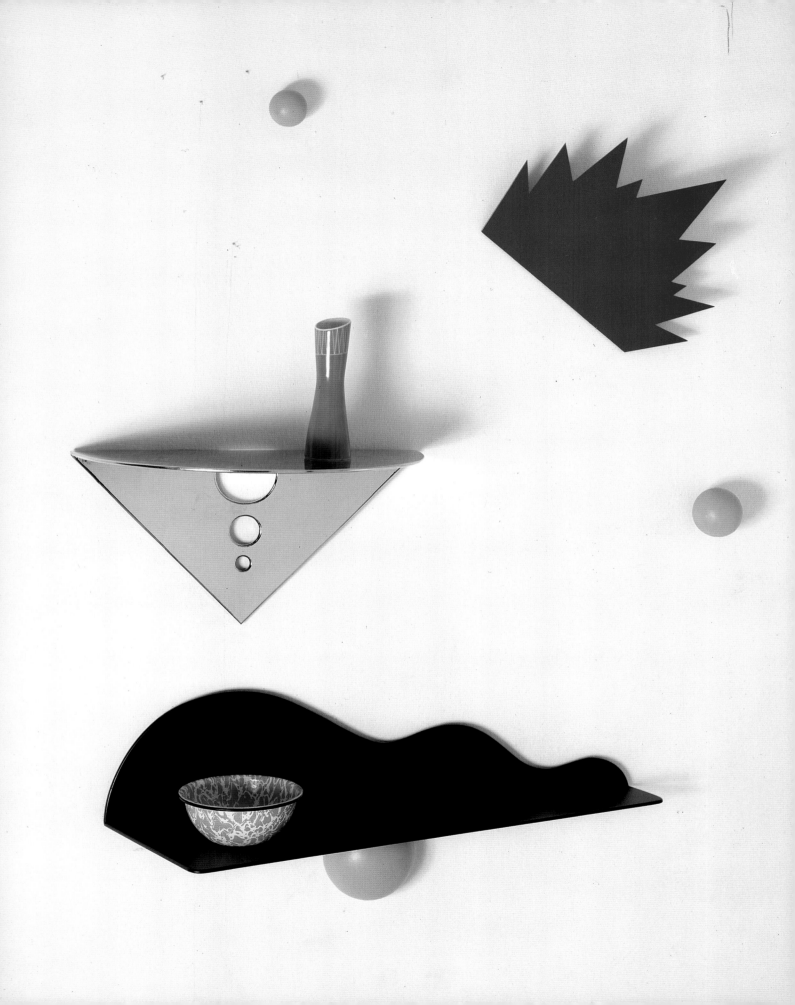

Preface

Like many aspects of society, design is in a state of crisis. It is a profession born of idealistic notions about the quality of human-made objects and environments, but it has been losing a sense of purpose to the prevailing values of commerce. Functionalism, universality, and timelessness, once the hallmarks of modern design, no longer seem adequate. Social injustices, economic recession, uncertainty, intolerance of difference, and diminished resources have encouraged a regression toward a comfortable nostalgia rather than a radically new response. Shifting priorities and state-of-the-art digital technologies are driving a wedge between old and new generations. The difficulty of distinguishing between the natural and the artificial is obscuring traditional criteria of beauty and authenticity. Both artists and designers, working as if they were from separate planets, are seeking a sense of balance and optimism in a world apparently moving toward either cultural conformity or increasing chaos. All of these factors create tremendous confusion, especially for students entering the visual arts.

How are they to respond at the end of a millennium to conditions that to many people indicate the end of history, the end of nature, the end of art, and the end of humanism and reason? I am a devoted advocate of change, but I am not so skeptical about our condition. While I relish the idea of the multiple realities suggested by "postmodernism," I find the pronouncement of the end of modernism premature and reactionary. Just as I began in the 1960s to question the rigidity of an orthodox modernism, in the 1990s I find myself questioning the divisive jargon and anarchy of those who suggest that modernism is something we must overcome. I have worked to redefine functionalism and at the same time supported attempts to shake things up radically, even if those experiments trifle with *antifunctionalism*. I acknowledge cultural imperfections,

tensions, and contradictions, yet I believe that modernism still evolves as a rich project of inquiry. The connections that once gave continuity to our visions are coming undone; the new question is not whether the ambition for continuity still makes sense, but what ideas we will assemble and how we will relate them to each other. Radical modernism is therefore presented here as a reaffirmation of the idealistic roots of our modernity, adjusted to include more of our diverse culture, history, research, and fantasy.

I have chosen to define my position as that of an artist whose subject — design and culture — affects all aspects of life. This means that design has turned out to be not so much my career as a way of expressing, confronting, even struggling with dramatic personal and social changes. I have been first and foremost a practitioner who advocates aesthetic quality. As the following pages will show, my pursuit has produced a body of rather diverse (yet homogeneous) work over a period of twenty-five years, marked by excursions into various disciplines and often motivated by design theories and cultural issues. Throughout this time, in whatever area of specialty, I have willfully maintained the perspective of an outsider. My goal in working in the "margins" has been to find a fresher view into the center of things. From this position, I have questioned the values we now use to distinguish between art and design, the public and the private, the domestic and the institutional, in an effort to visualize a modernism based on a radical reconception and an optimistic new agenda.

ASTRAL, 1990. Set of fragmented wall elements made with painted wood and metal and nickel-plated metal. Collection of Pinky Wolman in New York City.

My work crosses existing boundaries
between the various disciplines of art and design.
The intention is not to dissolve distinctions
but to explore how each might
inform the other.

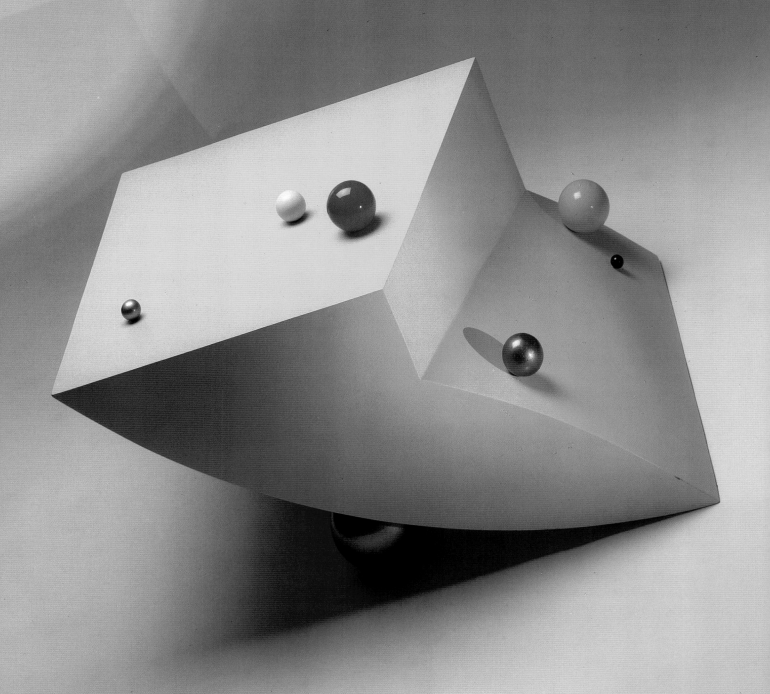

CHEMISTRY, 1989. Low table of painted wood and medium-density fiberboard, 38 x 64 x 61 cm.
Collection of Pierre and Thérèse Ampe in Paris.

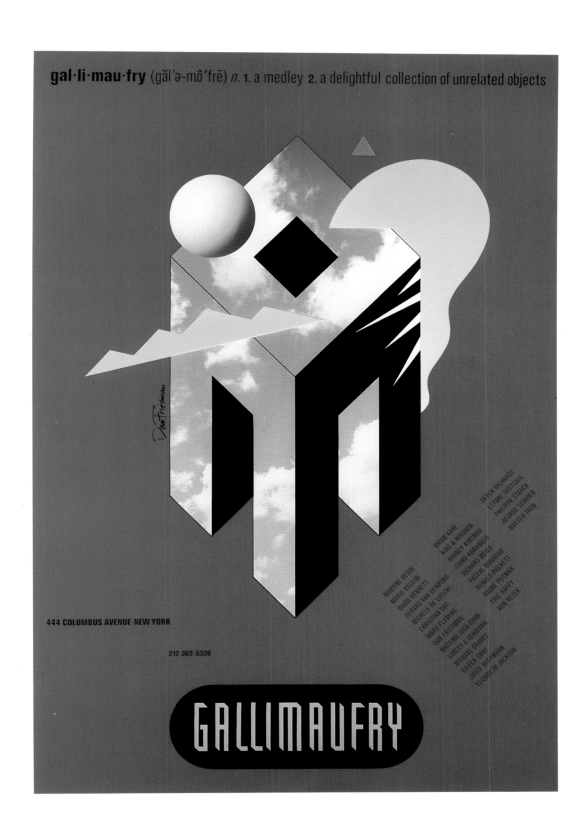

GALLIMAUFRY, 1987. Poster for a New York shop for modern household objects; includes logo along with symbol transformed with color and photographs. Collection of the Cooper-Hewitt Museum in New York City.

WILLIWEAR, 1989. Insignia for an American fashion company.
The use of black and white had already been established as a company theme.

WILLIWEAR, 1987. Partial view of the furniture and interior design for a clothing store in Paris.

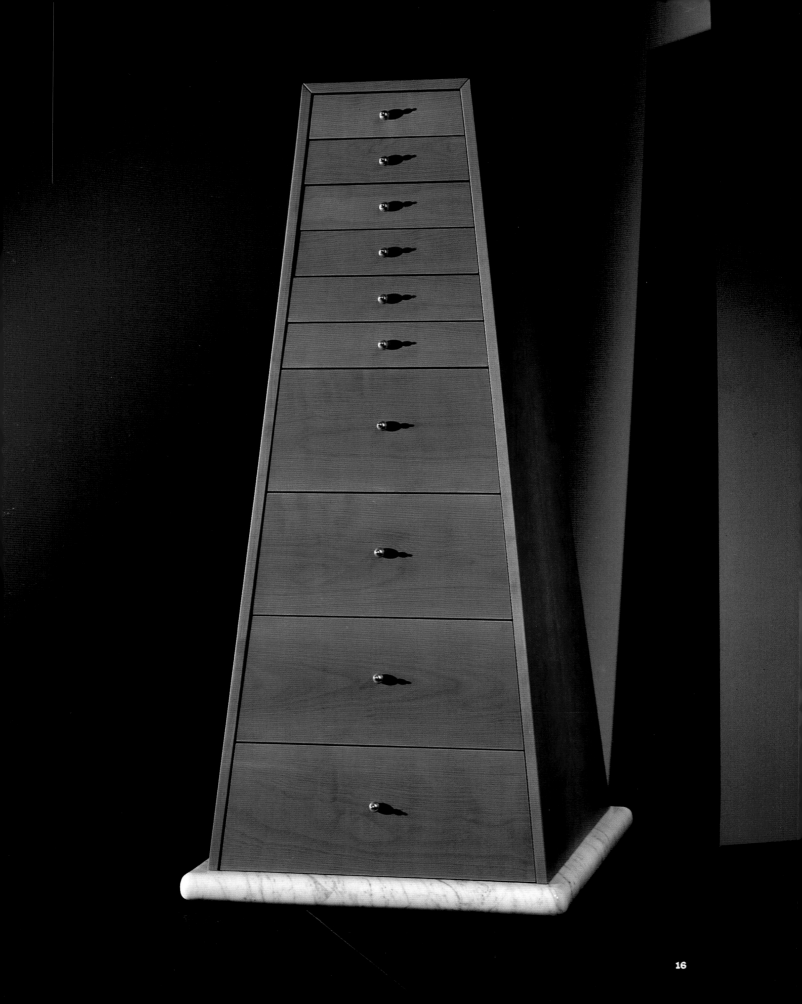

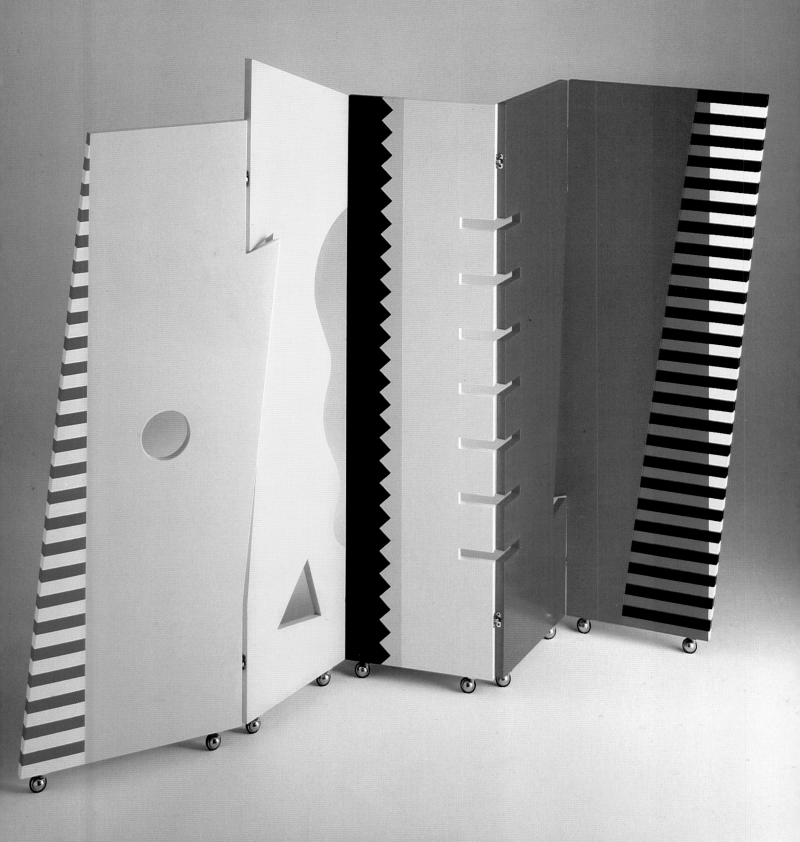

BAGATELLE, 1992. Folding screen made with hand-painted medium-density fiberboard, 170 x 223 cm. Produced by Driade in Milan.
MIDA, 1992. Cabinet (opposite) made with wood, marble, and special three-ball cast-aluminum drawer handles, 160 x 72 x 72 cm.
Produced by Arredaesse in Milan.

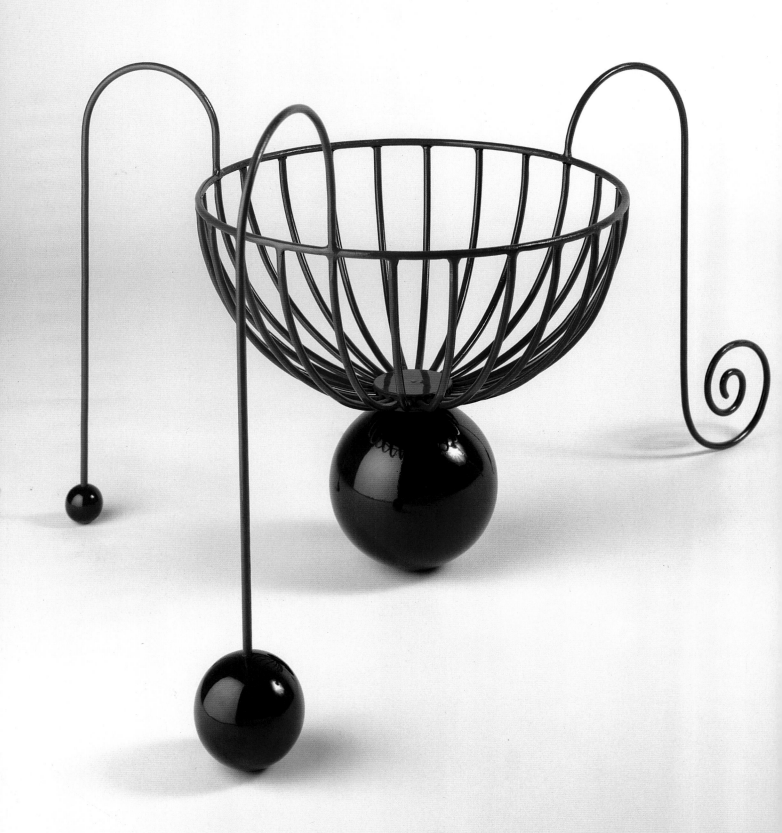

WAVE HILL, 1991. Fruit basket made with painted wood and metal. Produced in limited edition by Neotu in Paris.

Esto

quod

esse videris

♥

[Omnia]

vincit

→ amor

Ars

est longa

vita brevis

Typographic elements created as decoration for a ceramic vase produced by Alessi in Milan, 1991. 19

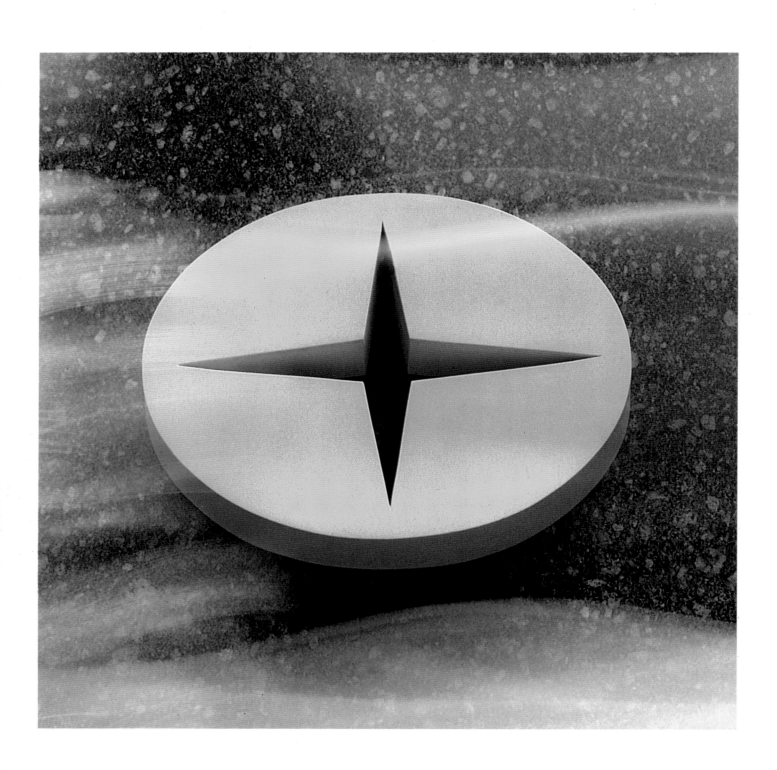

CITIBANK, 1975. Architectural plaque of the Citibank symbol (see page 136).
POSTNUCLEARISM, 1984. Detail (opposite) of an installation at the Red Studio, a New York City gallery; includes geographic tables, *Fuzzy Dice Screen,* and "charred debris" (see page 97).

BORN IN OHIO

HOMEBOY

Design and Culture

There was a time when designers were cultural visionaries leading society. They spoke of a visual landscape enhanced by artistic quality, inspired by new techniques and concepts, and created to promote a sense of liberation and enrichment. In its infancy, design was tied to the ambitious aspirations of art, architecture, and technology. Many modern designers (such as William Morris, Walter Gropius, and R. Buckminster Fuller) extended this ambition by seeing design as part of a mission that embraced considerably more than isolated issues of technique and style. Even though monolithic views of culture have proven to be impractical and the aspirations of industry have prevailed more often than those of art, design is still inspirational when it evokes the spirit of idealism and radical cultural change that was fostered by early modernism.

The obstacles designers now face in maintaining idealism are innumerable and well known. Undercurrents of disaster and fear have surely had a subliminal effect on the way we design or value our lives, our culture, and our environments. For example, my birth only days before the first atomic bomb was deployed must have left an imprint on my imagination. The chances of nuclear apocalypse may or may not have diminished with the ending of the cold war, but there are always new demons to fear. The world crisis of AIDS, crime, terrorism, "ethnic cleansing," environmental devastation, and massive financial deficit are the newer "bombs" that threaten to destroy us. Dystopia has become an integral part of culture, and through the medium of television it has entered our homes and become a part of every domestic landscape.

The radiant energy of television has effected a profoundly new kind of electronic space — a human-made environment that delivers a continuous barrage of illusion, urgency, intensity, simulation, and violence. It electronically transports us through time and space. As Marshall McLuhan

Entropy is a part of culture often marked by cataclysmic events such as the atomic bomb explosion over Japan in 1945 or HIV particles budding from the outer membrane of a T lymphocyte.
BORN IN OHIO, 1991. Announcement (opposite) for an exhibition of my work at the University of Akron.

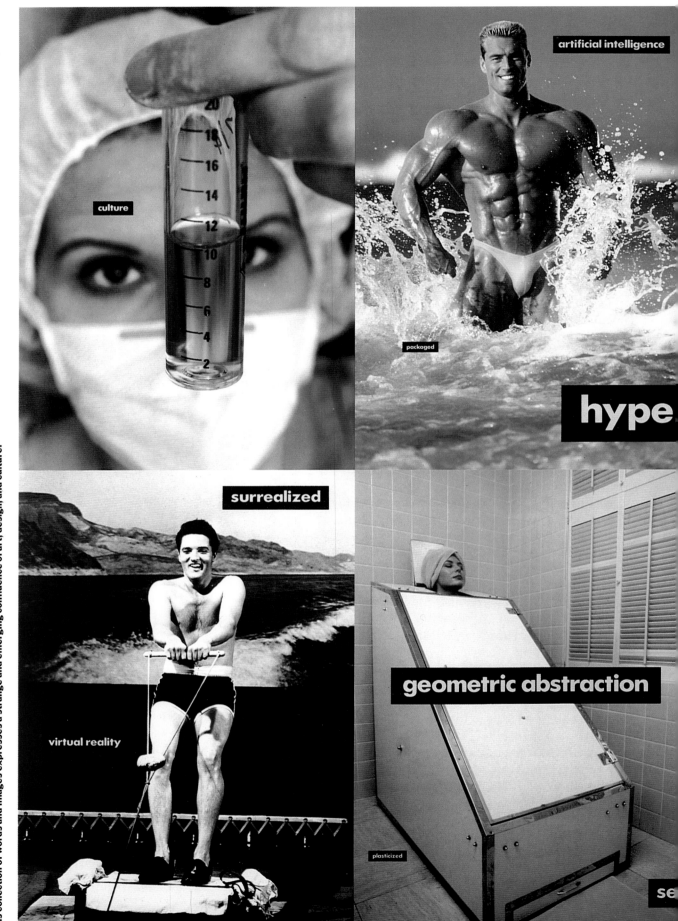

suggested in the 1960s, it alters everything from our sense of color to our sense of community. The accessibility, diversity, and random juxtaposition of televised information makes everything equally important and unimportant. Television is blinding, numbing, addictive, seductive, and toxic. It has prepared us to be sucked into a kind of hyperspace — an electronic city that is radically new in structure and that could never have been conceived solely by architects or designers.

Does design have a visible impact on every aspect of culture, or is its influence minuscule? If one equates "design" with products that are the result of styling and expediency, then it can be considered pervasive. However, there is only marginal evidence (on television or in "real" environments) that the civilizing aspirations of an art-based but user-friendly design play an important role in the culture of America. Urban design is less a reflection of designers' vision than of the complex compromises made between real estate developers, bankers, contractors, community boards, and politicians. Similarly, product designs are typically formulated by marketing experts, corporate strategists, computer analysts, cost accountants, merchandisers, and media consultants. Aesthetic, humanistic, and pragmatic innovations remain an isolated "luxury" and a diminished priority, often replaced with designs that breed confusion or worse: alienation, fear, indifference, envy, or exhaustion. This is hardly an antidote to the violence, greed, pain, loss, and prejudice already suffered by many members of society.

Museums (and schools) have not yet substantially made their contributions toward integrating design into the context of our rapidly evolving culture. Their old distinctions among art, design, crafts, and decorative arts do not still provide a satisfactory logic. Some museums have spent the last

thirty years frozen in earlier conceptions of modernism and are confused about what is now important. Certain archetypal objects of design (such as posters) are still collected, celebrated, and envied even though they have become a diminished aspect of what designers now actually do.

Designers have dedicated themselves so entirely to the private sector that the public realm, cherished in other times and places, has languished. A preoccupation with the aspirations of business has made design overspecialized and resistant to becoming a more engaging part of a larger culture. Design, like society at large, has suffered from a vacuum of inspirational leadership. In the last decade, and perhaps for much of the modern era, a correlation has become apparent between our quality of life and the powerlessness of designers to contribute to the public good. There is already evidence, however, that the 1990s may see a reemergence of designers with a more determined social conscience and an understanding of the words *pro bono publico.* Moreover, our marginalized position may inspire us, like artists, to function once again as cultural provocateurs.

The newest technology and design have always fostered a powerful mythology of progress. Experience throughout this century has not always shown us whether our new "superhighways" progress toward liberation and protection or toward sacrifice and vulnerability.

Design should be repositioned so that it is viewed more as an enrichment to culture and not only as a service to business.

These views of the *Home Shopping Network* (above) and of downtown Los Angeles (opposite) reveal a mood of alienation in spite of a backdrop of highly sophisticated, modern technology. Human-made environments are less the result of design and too often the result of expediency, the baser imperatives of commerce, a desensitization caused by overexposure to brutality, and the separations between "us" and "them."

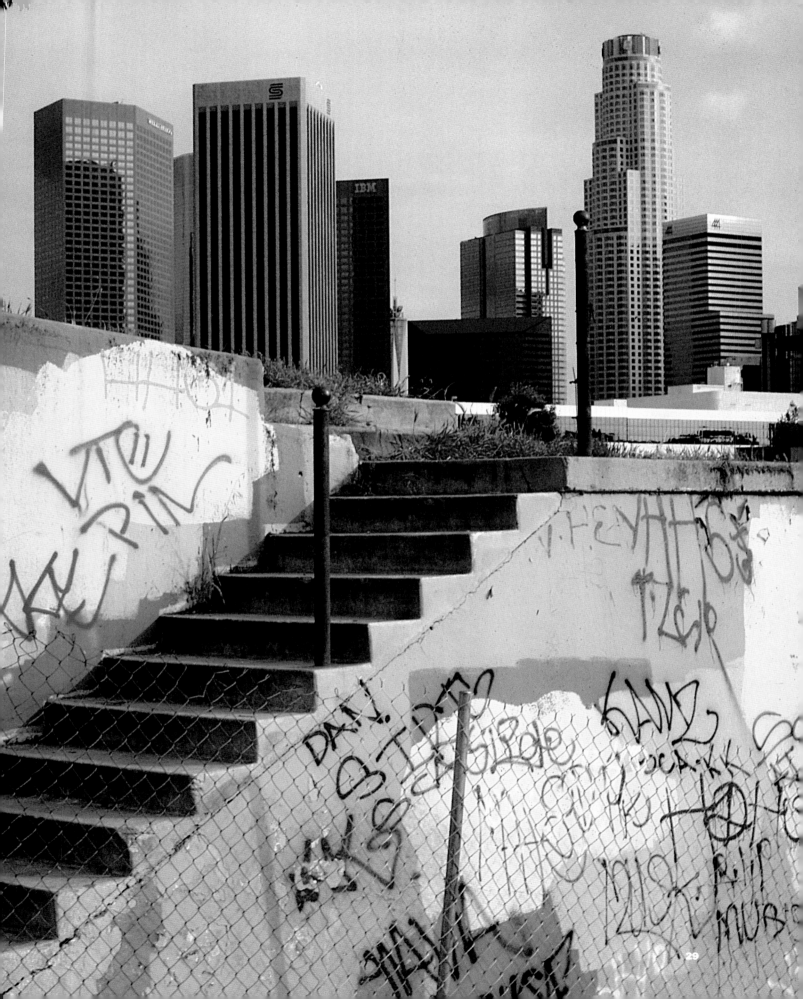

Metaphorical Utopia

When I began working in the 1960s, graphic design was still emerging from what was known as commercial art. As a rather new discipline, graphic design had a very narrow critical or theoretical basis, so we looked to the history and critical theories of related pursuits such as art, architecture, linguistics, and music. At a time when design in America was perceived as a marginal aspect of marketing or decor, we looked to Europe, where design research as an *aspect of culture* has usually been more sophisticated.

After studying design in Germany and Switzerland, I returned to America in 1969 to continue this research and to teach. The country was in a state of turmoil and polarization. Yet it was also a time of liberation, idealism, and experimentation — a time considered by many to be a cultural turning point. I believed that this new spirit of the 1960s could also reposition the design profession so that it would contribute more significantly to a better human condition and outlook. At the beginning of my professional life, this became my context for defining the role of design, reminiscent perhaps of the optimism of an earlier modernism.

With each poster or typographic composition I designed in this period, I thought of myself as a designer no larger than a letterform — one who organized small environments using only the graphic designer's inventory of hand-drawn forms, photography, and typographic elements. Having been inspired by urban and information theory, I tried to create the same kind of idealized patterns, messages, signals, spaces, pathways, and structures in a two-dimensional field that might be created on a larger scale in an actual public space. I fantasized that my miniature places demanded the same sort of challenges or amenities that a full-sized pedestrian would desire in any real place. In so doing, I attempted to position graphic design as a more theoretical form of discourse (even though I often quietly disguised it as an experiment in pure visual form). This was based on a more European perception of art and design as a means of being socially engaged. No matter how small a design project might be, it was to be considered as a metaphor for a broader, holistic context.

This imaginary shrinking of size was part of the creative process in nearly all of my designs. It was most obvious in compositions that appeared more clearly to be landscapes. Creating an intimate relationship between the figure and the background of a composition is a metaphor for the universal environmental design problem of creating a *fitness* between the new and the old; between the human-made and its existing or natural surroundings. I was inspired by the landscapes created by ancient societies, which more easily maintained this fitness because of their use of locally available materials, their reference to idioms already tested

Dan Friedman as a student, walking in the Swiss Alps in 1968.
YALE SYMPHONY ORCHESTRA, 1973. Silk-screened poster (opposite) for a concert of music by Beethoven, Brahms, and Wagner.

through many generations, and their mythologies that defined spiritual connections between humans and the earth. Inherent within this fascination for real and abstract landscapes (especially those where the horizon is visible) is their potential as sources for transcendental reflection. They remind us that we are connected to the ground upon which we walk and that nature (in addition to cultural history) will always be our deeply ingrained reference point. I refer to landscapes in my work as a way of reaffirming this connection and of expressing symbolically the ecological and social responsibility all designers share for past and future human-made environments.

Traditionally, it has been the role of the designer to create order and clarity out of chaos and confusion. But the urban design movements of the 1960s suggested that most designers failed to recapture the universally admired qualities of the best world cities — cities that have evolved from the layers of past, present, and future values. Too often urban planners had difficulty in finding a balance between imposing their simple, abstract new order and accommodating the vitality that actually existed in the complex networks of urban life. Likewise, some architects (such as Richard Meier) designed buildings in a pure and elegant aesthetic, working in the tradition of Le Corbusier and against the cultural anarchy and disharmony of the day. Others in the 1960s formed an opposition, often attributed to Robert Venturi, which contended that the architect should express rather than exclude the dumb and fractured context of the real world.

I found an analogue to these issues in my own field of visual communications. I was attracted to the spareness, abstraction, order, and Zenlike purity characteristic of orthodox modernism (see page 34). But I was also intrigued by more hidden complexities; by the more vernacular; by working *against* the rigidity, boredom, and exclusiveness that were increasingly associated with modernism (see page 35). Most important, I was *not* prepared to see these points of view as inherently contradictory. As a student, I had already confronted two very different design sensibilities: the science-based rationalism of Ulm in Germany and the art-based, intuitive logic of Basel in Switzerland. Many market-based, pragmatic Americans naively found these significantly different sensibilities to be indistinguishable styles. I began to think about a reconceptualized modernism, more radical in that it would not only accommodate order along with chaos but would embrace a variety of other conditions no longer paired as dichotomies. Instead, they would be seen as a full spectrum to be acknowledged, used, and proportioned in any way appropriate. My vision of a modern utopia shifted to one in which a variety of cultural conditions would be simultaneously merged rather than polarized.

A view of the ancient city of Benares from the Ganges River in India.

**Landscapes have
always been a theme in my work because they suggest a source
for transcendental reflection.**

Indian Summer 1981

CIRCLE, 1978. Proposed symbol for a fashion company.
PINKY & DIANNE, 1981. A logo used in an announcement for a company that produces men's and women's fashion.

„Die Normannen kommen"

Regie: Giuseppe Vari
USA 1965

Filmdokument eV
Freitag
16 Februar 1968
Aula HfG

DIE NORMANNEN KOMMEN, 1968. A minimalist poster for a film showing at the Hochschule für Gestaltung in Ulm, Germany. Its characteristics can be described as simple, restrained, orderly, static, exclusive, abstract, pure, reduced, harmonious, systematic, and integrated. Collection of the Museum of Modern Art in New York City.

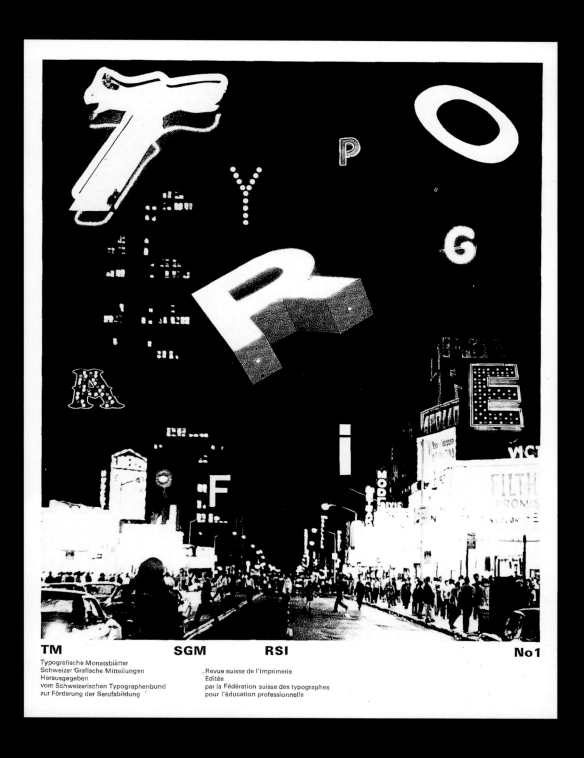

TYPOGRAFISCHE MONATSBLÄTTER, 1971. The winning cover design in a competition for a
Swiss printing and typography trade publication; a visual manifesto for a more inclusive typography
suggested by using abstractions of letterforms found in Times Square in New York City.
Its characteristics can be described as complex, excessive, chaotic, dynamic, inclusive,
vernacular, contextual, expanded, dissonant, random, and fractured.

A FALLEN SKY IN A REGAL LANDSCAPE, 1985. A metaphysical landscape made of painted plywood, aluminum, found objects, and an internal light fixture, 91 x 131 x 30 cm.

Visual Literacy

Visual studies in our educational system have been in need of radical reform for as long as I can remember. The artistic activities of young children are merged with other educational activities, but only at the very beginning, when play and learning are coordinated, a balance is encouraged between the mind and the body, and the priorities of the individual are differentiated from those of the group. As students progress this integration tends to break down. Sensory endeavors, such as those found in the visual arts, disappear into a side compartment, separated from activities of the mind. In high schools the arts are usually a minor diversion for "misfits" or for students of talent who may be encouraged, but only in the most conventional manner.

In the 1950s and 1960s the Swiss designer and educator Armin Hofmann foresaw the dehumanizing effects of segmenting the activities of doing, searching, and thinking. Hofmann proposed that there is a body of knowledge in the visual arts (as in literature, mathematics, and music) that can and should be taught at all levels of education, especially in a culture so dominated by the visual.

Basic design is a means of *introducing* the way one unifies doing, searching, and thinking in the visual arts. Its importance is diminished if it is seen purely as an exercise in making good form. Of course, good form is also desirable, but it has recently been deemphasized by designers who do not see its relationship to their more social or political agenda. The point is that it is possible to teach principles of visual form in a way that connects basic design to humanistic dimensions and to related social issues. As a teacher, I viewed basic design as a simplification of the innate logic in systems of visual perception, which is rooted in history and rationalism. Students cannot totally free themselves from this conceptual inheritance, no matter how much they may naively try. The best anyone can do is to learn its principles well enough to question, improve, adapt, or work against them creatively.

I therefore presented basic design as an *advanced* study of fundamentals. A limited visual vocabulary (dots, lines, planes, and so forth) encouraged students of diverse disposition nonetheless to share the same language in the process of isolating factors of perception so they could easily be discussed, observed, analyzed, played with, controlled, transposed, applied, and eventually assimilated as second nature. Students achieved simplicity not by imposing it in advance, but by reducing choices after sifting through a great variety of viewpoints. More important, this reductive process also provided the basis for discussing more fundamental and philosophical questions: How can we be freely creative while working within extreme limitations? How can we get two apparently antithetical systems to coexist? When might the priorities of a larger context compromise our own individual expression? Is there a correlation between what we say we will do and what we actually design? What are the possibilities of creating meaningful communication within the limitations of abstract visual form? Is communication more universal if it uses abstract rather than vernacular visual languages?

Part of a series (above and opposite) of basic design exercises executed by undergraduate students at the State University of New York in Purchase in 1973. The goal — to create a square composition of nine different but related shapes — was a lesson in composition, color, shape, nuance, and visual logic, with an emphasis on drawing.

These investigations within the visual domain could be introduced as an aspect of the humanities and made available to *all students* in secondary and higher education. Theirs could be a knowledge based not only on an appreciation of art history but more significantly on the new context of visual culture and the way design can penetrate every aspect of our lives. Education could be aimed at preparing a broader segment of society to appreciate the importance of visual literacy. And it could encourage students to extend themselves beyond specialized points of view. Presently, art schools push students at the beginning to choose between painting, graphic design, photography, and so forth before they have intellectually matured. Premature specialization in schools perpetuates a similar isolation in practice and works against the hybridization that is increasingly desirable in real professions. Graduate students attempt to generate advanced work whether or not they have the most rudimentary knowledge of the visual arts — knowledge which is often inadequately taught at a lower level.

Complicating the situation is a growing debate about the use of computers in the classroom. This debate affects all levels of education, but it highlights a special dilemma in regard to the training of designers. New digital technologies are dramatically transforming the design process. Developments in interactive multimedia will radically change visual communication in the future. Design schools have always been squeezed between developing a student's fundamental knowledge and preparing him or her for the practical needs of the marketplace. Now there is increasing pressure to master complex new technologies.

Our most significant challenge may be deciding what is valuable within the awesome amount of information choices instantly accessible to us with these new technologies, such as the hundreds of channels available on the emerging information superhighway or the thousands of typefaces which can be infinitely modified using new computer software. The big risk for the design student is that new technology provides the opportunity to create complex effects that tease the eye with their precision but often have negligible substance. Hypermedia may encourage random, impulsive, unpredictable juxtapositions of information, but they do not automatically create knowledge, understanding, and decision-making skills. Hofmann suggests that the more complicated the new processes become, the less transparent the principles necessary to perform a design task will be. Experts in all areas of education are expressing concern that the opportunity to use computers in the classroom may further undermine the teaching of fundamental knowledge.

In the typical scenario, design education usually begins as a specialization detached from the richness of the humanities. It ends with students being seduced by the marketplace or by the new technologies, while being obstructed from developing exactly the knowledge they need in order to make critical judgments. *Basic design* remains, however, the best exercise for introducing these kinds of choices on any level of design education.

OPERATIONS PERFORMED ON A LINE GRID, 1972. I supplied students with a simple line grid (infrastructure) and a few instructions. They were asked to perform an operation (process) of their choice on the line grid. The first step (six examples are shown on the opposite page) required each student to define, in the simplest and most generic way possible, the type of operation that would be applied. Each of these operations can be described as an intrinsic idea out of the large inventory of *visual syntax*. This initial step is a reductive process that involves clearing away extraneous elements or distracting information.

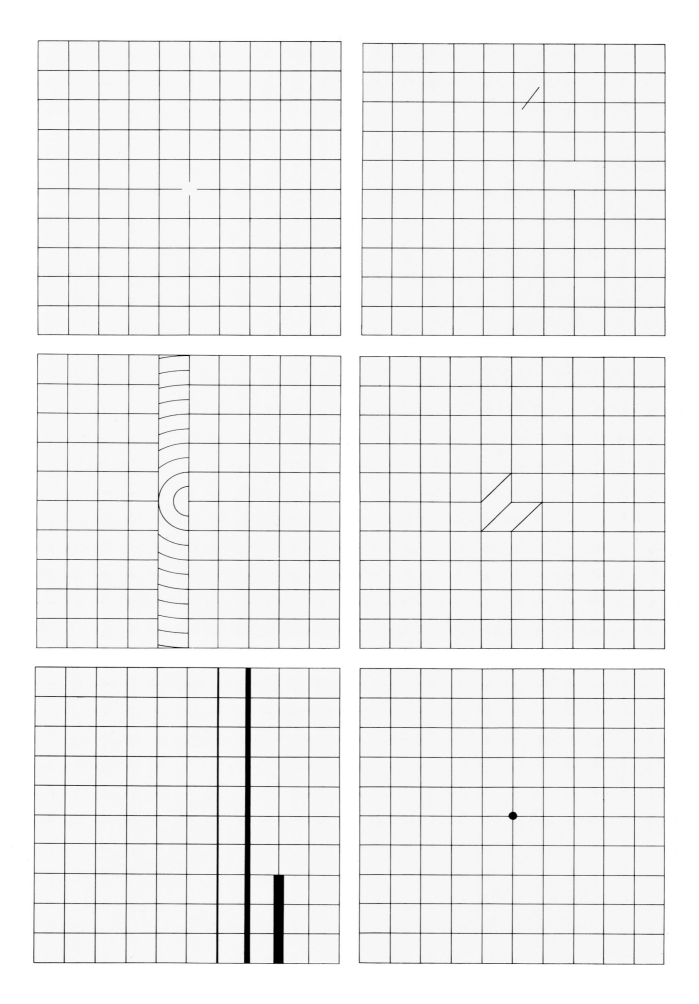

Basic design should not be confused with purely aesthetic and remote exercises. Instead it is an advanced study that introduces the way one unifies doing, searching, and thinking in all of the visual arts.

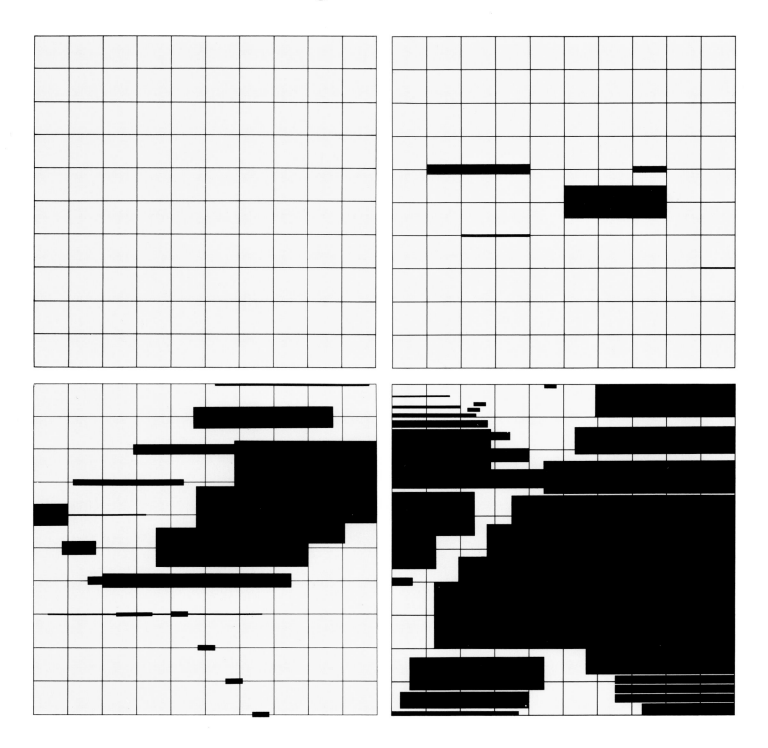

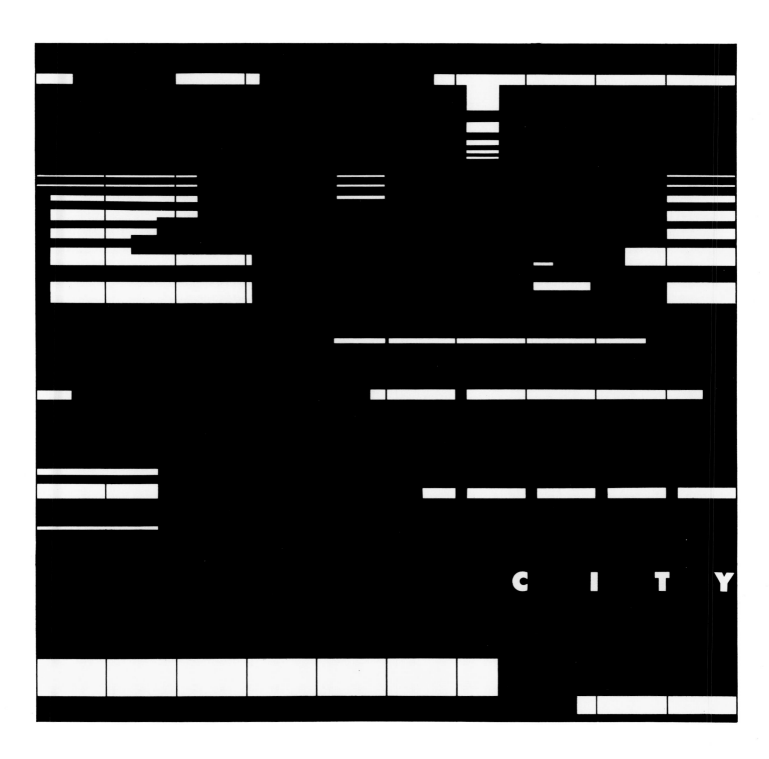

OPERATIONS PERFORMED ON A LINE GRID, 1972. The second aspect of this basic design
exercise involved the evolution from the existing line grid, to the definition of an intrinsic operation,
and eventually to the extension of that operation within the remaining images of a coherent series.
In this example, the student (Donald Moyer) randomly enlarged and shifted horizontal segments of the line grid.
In the last composition of the sequence (above), students were required to combine the word *city*
within the context of their chosen visual languages. One begins to observe the subtle
transformation when form and meaning coalesce. In this case, the original line grid is nearly
obliterated. It is an exercise in working within (or against) a given system.

The most encouraging recent phenomena in graphic design have been the accelerated development of complex discourse, the increasing attention to historical research and social objectives, and the frequently heated debate. No area seems more contentious than typography, which has been propelled into a new age by an extraordinary digital technology. The conflicts are largely generational, and the battles are often fought on moral grounds. For example, the older generation tends to find the greatest freedom working within restraints; the newer generation sees restraints as outmoded limitations. One group sees simplification as the route toward a more universal communication and feels a moral obligation to overcome pervasive visual pollution; the other sees simplification as an immoral act of exclusion and a form of cultural sanitization that impedes more diverse, complex, or personal expression.

This is the stuff of great debate. It reminds me of a period twenty-five years ago when we began to foster a *new typography,* even though our audience was much smaller. (At the time, the American Institute of Graphic Arts had about the same number of members nationally as it has today in New York City alone.) That period was also driven by technological change — the transformation from metal typesetting, often done by hand, to computer-driven photo typesetting. Schools were caught in the middle: most maintained a typesetting and letterpress printing technology that was fast disappearing, while looking ahead to a new technology for which they could not afford the equipment and materials. Furthermore, schools faced a pedagogical dilemma. Most of the terminology and the criteria for quality were inherent within metal typesetting

and a history that began with Gutenberg. Even the early modernist idioms of typography had been viewed as *natural* to letterpress technology. With the advent of photo typesetting, techniques that had existed for some five hundred years suddenly lost their foundation. The terminology was the same (leading, font, point size, and so on), but the technology no longer provided a reliable basis for determining line space, letter spacing, letter proportion, size, and almost everything else considered standard. Anything could be viewed as *natural* to the new technology — a preview to the digital typesetting revolution that began in the 1980s.

Typography is central to but surely not always the dominant aspect of graphic design. Although many have made it a specialization, I chose this direction only as a teacher during the transitional time of the late 1960s and early 1970s. What *beginning* students needed then (and still need now) was a reconceived methodology for understanding typography. It would be predicated on the principles of drawing, basic design, and new critical theories and less on the anachronisms of a rapidly changing history and technology. The methodology would be seen as a foundation of, not as a replacement for, personal expression.

Weather:
Sunny most of the day
but turning cloudy
with scattered showers.
High temperature: 52.
Colder tonite
with a probability
of snow flurries.
Low tonite: 29.

DYSFUNCTIONAL TYPOGRAPHY, 1970. A student's experiment with manipulating letterforms
was research into the thresholds of legibility and function in typography.
Disturbances in communication were called "noise."

We tha...

S... o f th... dy

bu t... cl... y

...hs ...d she

H.gh ...er

...d...r t...e

with ... B...ly

f... on A...e

W... te ...

In the 1960s, information theory defined art as the unpredictable state of messages.

My students often began typographic exercises with experiments in making messages *dysfunctional.* By studying progressive degrees of illegibility, we were able to establish acceptable tolerance levels. The methods of destroying messages I associated with "noise," a term borrowed from information theory to refer to disturbances in the communication process which guarantee that messages sent can never correlate exactly with messages received. This was an early attempt to relate ideas emanating from linguistic and literary theory to the study of typography, an association that has evolved today to the point where some designers now use poststructuralism as a source of inspiration. (It should be noted that the results of such inspirations can be unpredictable, but they are not always of scientific, aesthetic, or practical value.)

Another theory I developed in 1969 concerned *legibility and unpredictability.* This theory is still germane to the problem of communicating with typographic (as well as many other kinds of) messages. Legibility is by definition dependent on convention and a condition of "optimal" communication between sender and receiver (functionalism). Therefore, its characteristics in typography would normally require it to be orderly, simple, static, and banal, while it allows the reader to be a *passive* recipient.

The term *unpredictability* (or *readability,* as I called it in my earlier writings) was coined to describe an opposing set of conditions: disorder, complexity, dynamism, and originality. This characteristic in typography requires the reader to be an *active* recipient and is more dependent on the receiver than on the sender to formulate the message. Unpredictability promotes interest, pleasure, and challenge in reading. It implies that the design/text is open-ended, fractured, and ambiguous, which means that a reader can create his or her own multiple interpretations. Because the reader is confronted daily with so much (legible) information

from which to choose, it may be the characteristics of unpredictability that will entice the reader in the first place. (The opposite could also hold true as the characteristics of unpredictability eventually become conventional.) These early experiments with their progressive degrees of fracturing messages preceded by many years the functionalism-versus-antifunctionalism arguments that continue to prevail today.

It is risky to concentrate typographic investigation at either end of this legibility/unpredictability spectrum. For those concerned primarily with legibility (conventional functionalism), the creative potential of seeing from an entirely different perspective will be unexplored. For those primarily interested in unpredictability (considered by some to be a characteristic of postmodernism), there are potentially greater risks. (I say "greater" because I tend to have a special sympathy for the natural predicament faced by those who opt for the radically unconventional.) First, overspecialization in an extreme, experimental typography can marginalize designers by enabling them to avoid the more complex problems of graphic design. For example, the typographic identification on medical equipment or highway signage would not appropriately lend itself to multiple interpretations by the reader. Second, visual experiments with layering, deconstructing, and manipulating are often verbally rationalized as expressions of our contemporary milieu, even though others interpret them simply as more garbage in the worldwide glut of indigestible information. Third, experiments with unpredictability have come to depend on a common set of idiomatic elements which carry their own visual and linguistic codes and operate within a rather closed network of converted readers and believers. Extended further, this suggests that each form of unpredictability can become one more stylistic trend which is eventually appropriated by the market at increasingly accelerated speed. It may reach a larger audience but in the process may be stripped of its meaning (in the manner of the formalistic New Wave or nearly defunct Postmodern styles).

These risks also suggest that graphic designers should work past some rather naive positions. It may be an illusion that the newest orientation to typography is automatically better and has more layers of meaning than previous experiments that were either more or less concerned with formalistic possibilities. It may also be an illusion that the new digital technology now transforming typography has a higher authority and represents a kind of progress, considering that technological progress has often caused some erosion of human values. All newer generations tend to claim a better grasp of reality than former generations (and vice versa). The more cynical will suggest that nothing remains to be invented. And the novice chroniclers of design history tend to have fundamentally self-serving or superficial interpretations. Meanwhile, those less open to experimentation and expansion resist inevitable changes.

Radical modernism acknowledges our existing culture, conventions, and history contrasted with the creative spirit to question and reconceptualize. In relation to typography, radical modernism includes the full spectrum from legibility to unpredictability. New theories regarding typography should acknowledge the potential of this entire spectrum rather than take sides on one end or the other. There are now glimmers of hope that polarization will fade between these entrenched generational positions and between those who design with typography derived from either traditional or digital techniques. The most encouraging development is that what were lonely conversations twenty-five years ago are now part of a lively discourse among designers in many countries.

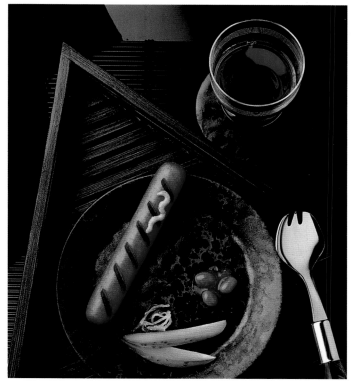

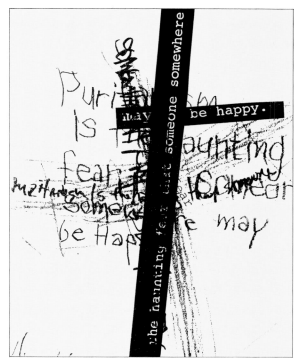

Like *nouvelle cuisine* (above), new typography often suffers from being "too creative" and therefore seems remote or indigestible to many people. The typographic exercise by a Yale University student (Matthew Lynaugh, 1992) explores an expressionistic interpretation of a message: "Puritanism is the haunting fear that someone, somewhere may be happy" — H. L. Mencken.

Weather:

Sunny, hot, humid
today and tomorrow.
Fair and warm tonight.
Temperature range:
Today 96-75
Tuesday 94-72

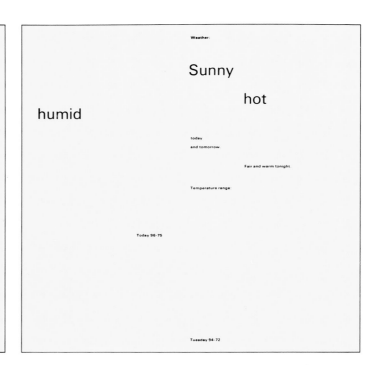

Weather:
Sunny

hot
humid

today and
tomorrow.
Fair and warm
tonight.
Temperature range:
Today 96-75
Tuesday 94-72

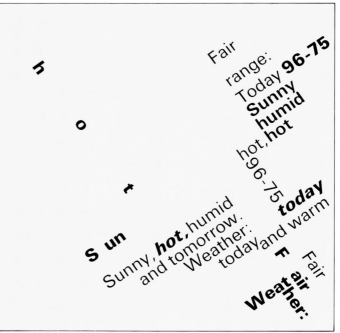

WEATHERING INFORMATION, 1970. Examples of the results of research mainly by one student, Rosalie Hansen Carlson at Yale University. Students were given a rather ordinary, unemotional message (weather report), set initially in a rather modern typeface (Univers 55).
They were asked to use it as the basis for both *syntactic and semantic* investigations using the possibilities of the "normal" typographic inventory. This was an exercise for beginners to observe states of simplicity and complexity, the normal and distorted, the static and the dynamic, and their effects on legibility and originality. First published in "A View: Introductory Education in Typography," *Visible Language* 2 (Spring 1973): 129-44.

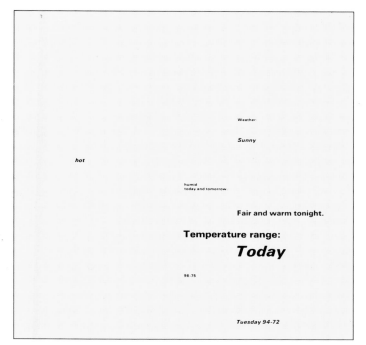

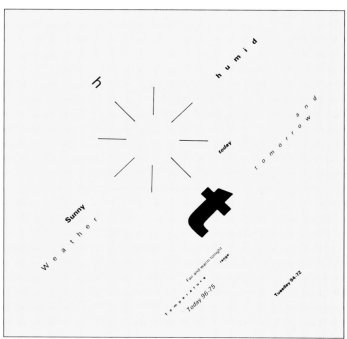

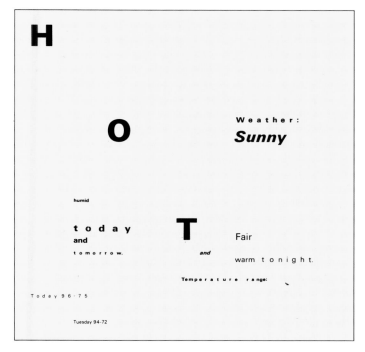

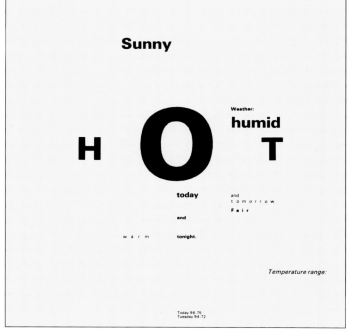

December

December 3 thru January 12
Student show: Drawings by students in the Division of Visual Arts. In the Conservation Room on the third floor.

December 15 thru February 15
Exhibition of Isak Friedlander etchings and woodcuts. In the Prints and Drawings Gallery on the third floor.

December 5
Lecture by Michael Kan, Curator of Primitive Art at the Brooklyn Museum. "African Art: Traditions of Connoisseurship"

8:00 PM at the Museum. Museum open for viewing at 7:00 PM. Reception following. No admission charge.

Neuberger Museum
SUNY
College at Purchase
Purchase,
New York
10577

U.S. Postage Paid Non-Profit Organization Permit No. 5 Purchase, New York

December

Neuberger Museum

EVENTS

EVENTS

We need to know how many plan to attend the lecture by Michael Kan Please return this card

YES I would like to attend the lecture by Michael Kan on December 5th.

Name

Address

Neuberger Museum

NEUBERGER MUSEUM, 1973. A monthly announcement of museum events produced ten years before the Macintosh, when typewriter, press-on type, and hand-drawn elements were used to produce low-budget projects.

50

Received:

Application

Portfolio

Application fee Statements

Photographs

Faculties in Design and Planning

Y A L E

Name in full Valid until

Permanent home address

Current mailing address Country of citizenship

Date and place of birth Occupation Are you married?

Name of parent or guardian

Address Address

Wife or husband's name

Social Security no. Degree (received

Field of major:

If you believe you will have need for finan...
your request will be considered apart from...
for admission. Applications for financial a...
obtained by writing the Registrar, School o...
Architecture, School o...
February 1. Application must be filed no...

Yale University
School of Architecture
New Haven, Connecticut
06520

Y A L

Y A L E

UNIVERSITY

M. ARCH.

Application for admission as a candidate
for the degree of Master of Architecture

School of Art and Architecture

Check List:

1.
Applications must be carefully filled out and
submitted together with all supporting material
not later than February 15 of the year for which
admission is anticipated, accompanied by:
2.
The application fee of $20.00, payable to
Yale University (not refundable).
3.
An official transcript of the academic record
for your college degrees.
4.
Transcripts should be accompanied by a catalog
or by descriptions of prerequisite or professional
courses.
5.
Evidence of aptitude. A portfolio (size not to
exceed 8½" x 11") with examples of paintings,
drawings, prints, graphic design, sculpture,
furniture and designs. Photographs may be
submitted in place of originals. Slides may be
submitted only when it is difficult to describe your
work in any other medium.
6.
Medical certification (see back page).
7.
Completion of the Graduate Record Examination
(GRE) or (if applicable) the Test of English as
a Foreign Language (TOEFL).
8.
Statements regarding your personal history and
purpose in applying to this program.
(see back page)

Address all communications to the Committee on
Admissions, c/o Registrar, School of Art and
Architecture, Faculties in Design and Planning.

Notification of admission or rejection will be
sent and portfolios returned (postage must be
prepaid by candidate) about a month after the
filing deadline.

Check List:
For the use of the Regist

Received:

Application

Application fee

Photographs

Applicatio...
for the deg

for the acad

List any speci
concerning yo

Y A L E

...on as a candidate for
... Environmental Design

... beginning:

...tions
...lication:

Valid until

Are you married?

...ity no. Degree & Date
 (received or expected?)

Accepted & not

Not accepted & notified Date

Tuition deposit

Transcripts:

Present military status Dates of
 attendance: major:

Colleges attended,
listed in chronological order:

Applicants should request writers to send
letters directly to the Committee on Admissions,
c/o Registrar, School of Architecture.

At least three references who relate to
...eriences which you have described:

References:

YALE UNIVERSITY, 1971. Application forms for various departments in the School of Art and Architecture; departments are differentiated by color and by cover pages using "illustrations" in the linear idiom of the form itself.

CHANGE OF ADDRESS CARD, 1978. There was a recurring theme in my typography of the 1970s. Spontaneous, hand-made characteristics were used to work against a process which is normally mechanical.
PINKY & DIANNE, 1980. A die-cut New Year's card (opposite) for two fashion designers; illustrates the use of typographic abstraction pushed to the edge of legibility.

Have a great new year!

Pinky Wolman & Dianne Beaudry

THE JACOBS COLLECTION

FOLLY, 1991-93. A set of four "double" flowerpots in terra cotta; each pot is 50 cm tall and can be inverted.
Produced by Alessio Sarri Ceramiche in Sesto Fiorentino.

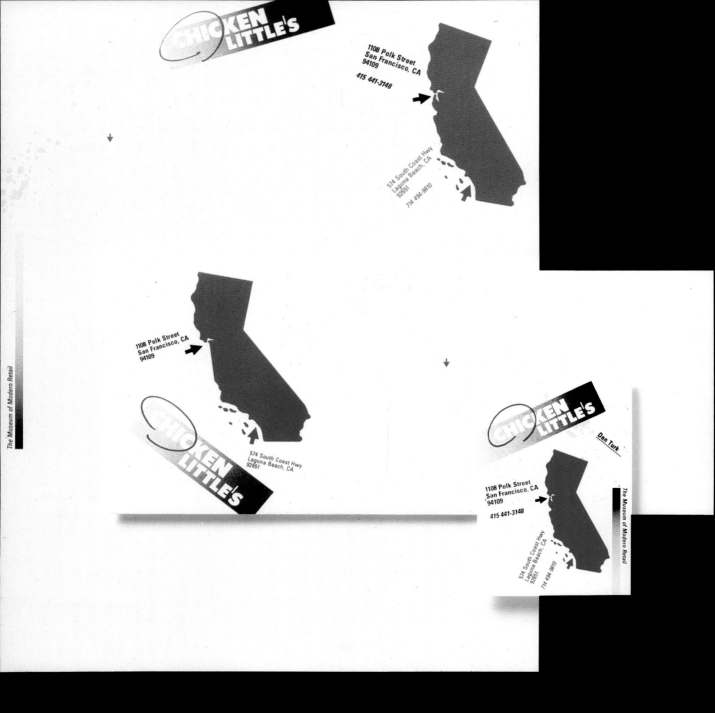

Dan Turk

CHICKEN LITTLE'S, 1978. Elements of a visual identity for a California boutique; spontaneous, hand-drawn, and asymmetrical qualities are used as a *looser* idiom for creating a coherent system of objects and were a strong reaction to the static characteristics of the prevailing "International Style." The sales order form (opposite) is an example of the *layering* of functional and decorative elements, organized so that each layer does not destroy the clarity and function of the other.

60

Name

Address

Telephone

CHICKEN LITTLE'S

Duns: 04-433-6642

Purchase order no. D 8067

Date

Terms

Shipping Instructions: Starting Complete Cancel after Ship via

Ship to: 1108 Polk Street
San Francisco, CA
94109
415 441-3148

574 South Coast Hwy
Laguna Beach, CA
92651
714 494-9810

Category	Style no.	Color	Description	26	27	5 6 28	7 8 29	XS 10 30	S 12 31	M 14 32	L 16 33	XL 18 34	20 36	38	40	42	44	Quantity	Cost	Total

1. We are not responsible for purchases unless made out on this order form and duly authorized by a responsible signature

2. If the terms specified on this order do not appear on, or agree with, the seller's invoice as rendered, seller agrees that purchaser may change the invoice to conform with this order and make payment accordingly.

3. Merchandise arriving after date specified, or not as ordered, is subject to refusal or return of part or all at vendor's expense, for both incoming and outgoing shipping charges.

4. Merchandise accepted as ordered only. No substitutions accepted.

Authorized signature

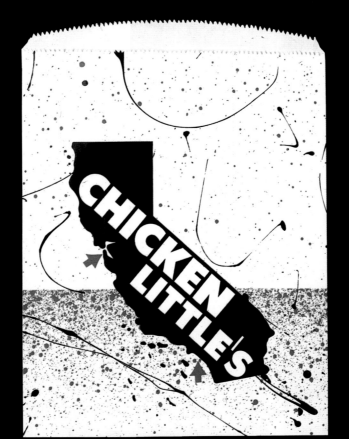

61

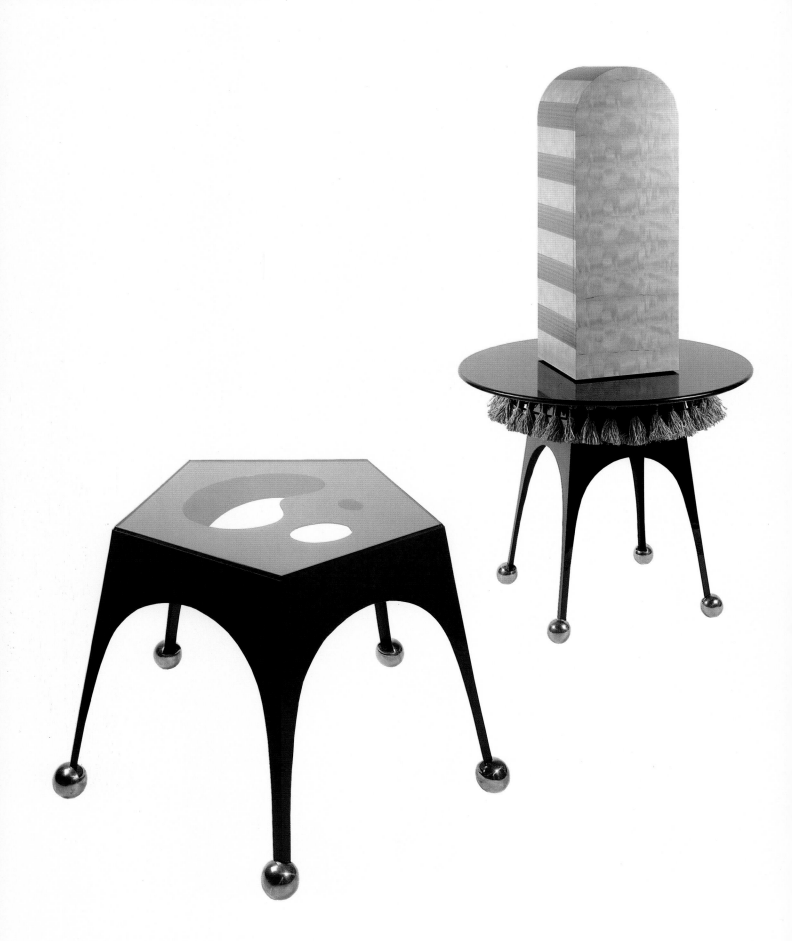

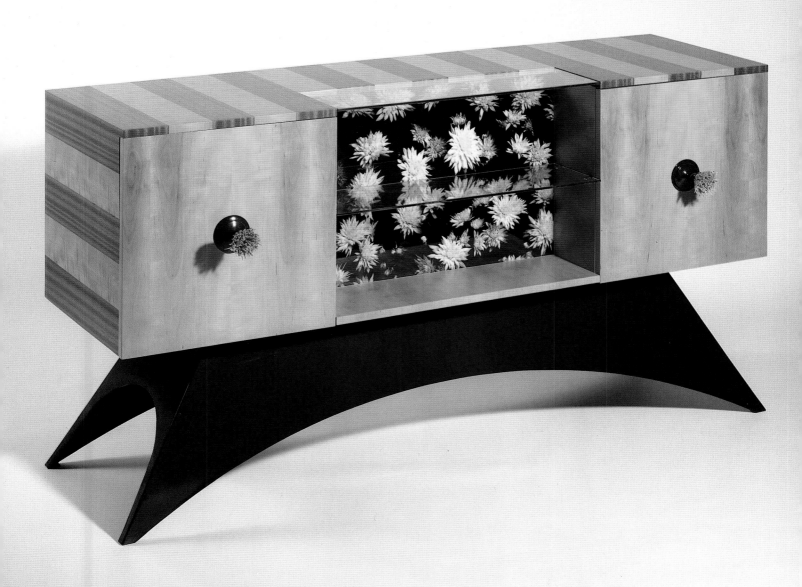

GRAMMERCY, 1991. A cabinet (above) made with back-lighted photograph, wood veneers, raffia, glass, and painted metal, 89 x 170 x 50 cm. These three pieces are part of the *Green Pieces* collection produced by Neotu in Paris.
LIBERTY, 1991. A cabinet with table (opposite above) made with wood veneers, raffia, marble, painted and cast metal, 200 x 114 x 114 cm.
CENTRAL, 1991. A small table (opposite below) made with painted and cast metal and glass, 71 x 76 x 76 cm.

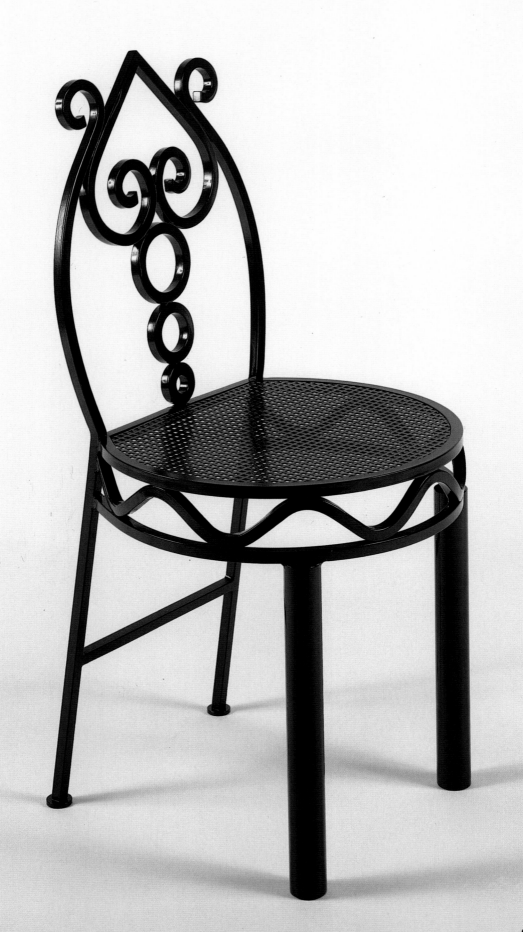

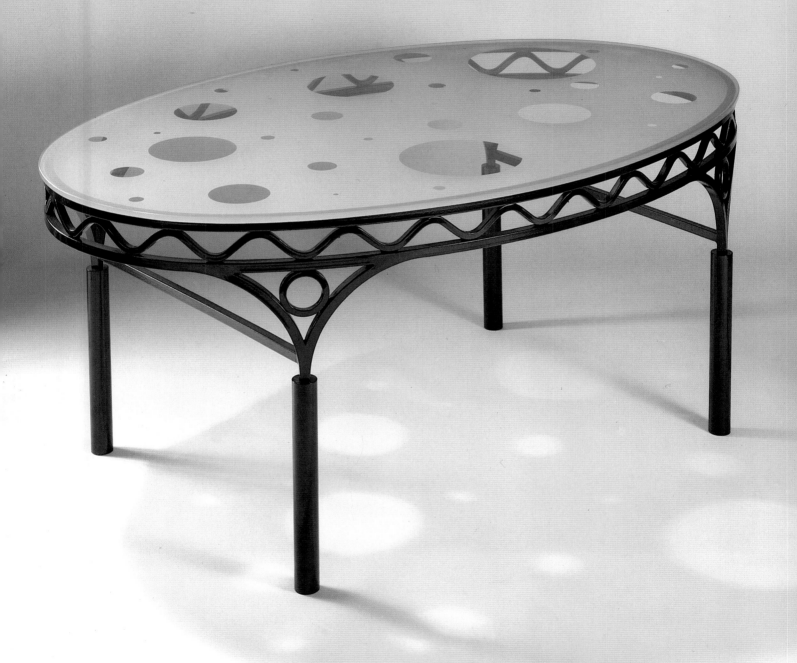

PROSPECT, 1991. A table for indoor or outdoor use made with painted metal and sandblasted glass, 182 x 109 x 76 cm.
CORONA, 1991. Painted metal chair (opposite), 91 x 43 x 43 cm. Both pieces produced by Neotu in Paris.

**I tend to favor
visual systems that aim toward coherency
while simultaneously suggesting
a degree of spontaneous
disruption.**

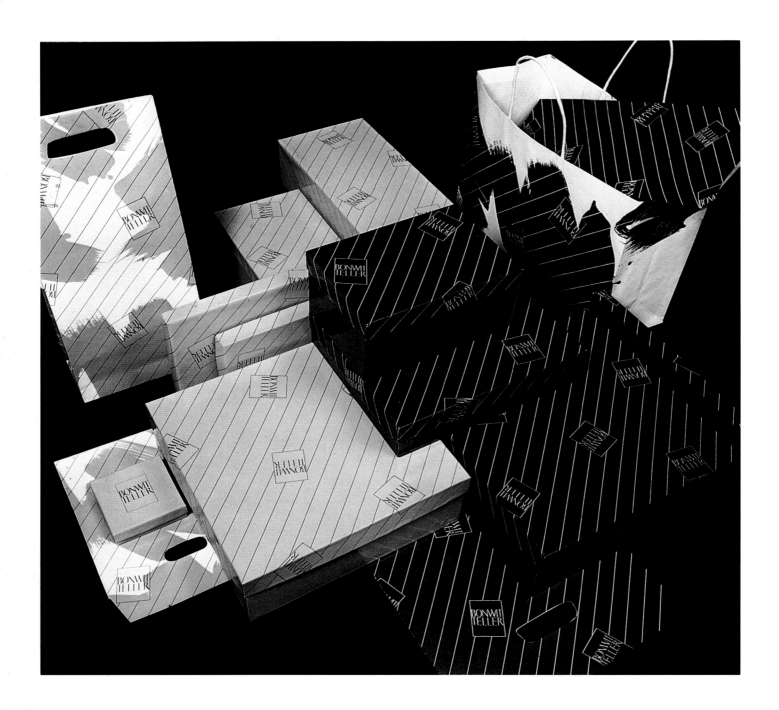

**BONWIT TELLER, 1976. Part of a system of various gift papers, boxes, and shopping bags for a New York City department store.
Proposed and designed while I was associated with Anspach Grossman Portugal, Inc.** 66

NEW ITALIAN DESIGN, 1990. Cover (above) and sample pages (opposite) of a book by Nally Bellati that surveys recent design in Italy. Published by Rizzoli.

NEW ITALIAN DESIGN

NALLY BELLATI

Introduction by Alberto Alessi

Design by Dan Friedman

RIZZOLI
NEW YORK

Today, at the beginning of the last decade of the second millenium, I am convinced that there is a distinct dichotomy emerging in the ways design is perceived. Two visions—often contradictory—occur.

On one side is mass production, with sales and standardization as its goal, which reduces the role of design to a tool for marketing and technology. The result: a world of anonymous products. On the other side stands the art, the poetry, the passion of design. In the last one hundred years this side of design has been expressed through William Morris and the Arts & Crafts movement in England and America, the Wiener Werkstätte in Vienna, the Deutscher Werkbund and the Bauhaus in Germany, and the Ulm School. The spiritual heir of these movements is the Italian design industries, whose nature is more similar to an applied research laboratory than to a conventional manufacturing environment.

Alessi has been honored to accept this inheritance, and with it the risks that come with breaking rules. We have attempted to crush technological rules in the same way that Gio Ponti, Carlo Mollino, and Franco Albini did with their furniture designs for Cassina and Arflex in the past. We have tried to avoid marketing rules, producing non-status quo items, in the same way that Achille Castiglioni, Mario Bellini, Bruno Munari, and Enzo Mari have for other Italian firms. And we make every effort to depart from the ruling figurative tradition in aesthetics and communications, in the same fashion we have observed Radical Design, Memphis, and Alchimia, and the figures we associate with those movements—Ettore Sottsass, Alessandro Mendini, and Andrea Branzi—do just that, with critical and—for us—economic success.

It is not a coincidence that this turmoil in rule breaking produces objects that do well on the market. Experimental design directions, usually financed by modest sources, are often adopted by big industry. The artistic side of design keeps raising questions and posing problems which big industry cannot answer and solve right away, provoking discomfort and uncertainty in those with their eyes fixed only on function and sales figures. We hope that new design will continue to provoke discomfort and uncertainty among manufacturers. The results and answers, if and when they are found, improve the environment for all design, of our culture, of aesthetics and technology, and of the marketplace as well.

We do not agree with the rigid, specialized, commercialized approach that big industry usually assigns "design." To categorize design as an offshoot of the fine arts, decorative arts, or applied arts is too old-fashioned. On the contrary, be it for external reasons provoked by changes in the world around us or for an organic growing and maturing process of its own, design is now entitled to its own specific, independent slot within the spectrum of the figurative arts.

This evolution, from a method of producing common objects to a global creative discipline, will not be complete until unexplored anthropological and sociocultural values are fully investigated. This will happen soon, in the 1990s, where the great magic of Italian design will be played on a new global field. As you meet many of these new Italian designers, some of whom have worked with Alessi in applying dynamic ideas in design to new products, remember it is they who will help to build my "somewhere," my "positive Utopia" (nowhere – no where – où topos – Utopia, to paraphrase William Morris).

Alberto Alessi January 1990

7

His political and cultural roots derive from the architectural events of the radical seventies. Influenced through experiences that brought him closer in the seventies to Conceptual Art and Arte Povera, today forty-four-year-old Franco Raggi ("Kin" to his friends) feels nearer to Minimal Art. Since the beginning of his career he has been intrigued by the classic architectural styles from Doric onwards. To him, they are perfect shapes of an abstract language: fascinating, timeless, linguistic nonsense—nonfunctional except from the point of view of symbolism and rite.

As a designer, he strives for an unrecognizable "style." His creative methods involve fussiness with almost invisible details. For every design he likes to stylistically reinvent a formal process, so that it will be ageless and have no relation to those before or after. He feels that if you can avoid a recognizable style you produce concepts that have significance.

Raggi is on the fringe of the design world, which he thinks of as a river, sometimes stagnant, sometimes churning with the excess of words that are spoken on the phenomenon of Italian design today. This lateral attitude is more interesting for him than an apparent central position, because it enables him to express himself in a more "surprising" manner compared to others who have a predictable style. Raggi's reserved, silent position doesn't look for instant recognition in magazines, in exhibition, or at social events. The "I'm also here" attitude is very far from his belief that the real results come when you don't expect them, or posthumously.

He often works outside the design world, in art, in publishing, or in the other fields known for their creativity. For five years he was an editor of Modo and then editor in chief for two years, an experience that he considers his most conceptual project to date, because it had to do chiefly with the communication of "the eye and the word."

In his work he finds restrictions fundamental. He says there is no such thing as a project without either technological, commercial, aesthetic, choice-of-medium, or psychological restrictions, because, in a creative exercise without them, everything becomes arbitrary. Raggi's relationship with production or technology is often "tell me what I can't do," and from there he understands what the true limits are. He works around them, combining different items and adding elements of novelty to technology. Like designing the electronic talking postcard for the "Neo Merce" exhibition at the 1985 Milan Triennale.

Raggi doesn't develop his projects in the regular way but tries to use everything that he comes across—chance encounters. He doesn't divide research from planning; his ideas come to him while he is working on something else. The romantic utopian objective of self-conscious scholarship does not interest him at all.

His chance encounters are with books, television, exhibitions, newspaper headlines, and life itself. He doesn't prepare himself for these, but his inquisitiveness creates the conditions for these encounters to happen and inspire.

He says that while being very curious, he is also very "lazy." He watches a lot of television and through the remote-control channel changing he creates a very disorganized metaphor for life: a condition of roving information; of visual, aural, and conceptual stimuli.

Raggi is currently attempting the hybridization of high-style decorations and poor materials, such as plaster. Enriching inexpensive materials and transferring them to objects and interior design revives ancient tradition and reproduces it in paradoxical references, so when inserted into a modern environment they produce a new relation between old and new. An antique piece of furniture can work well with something new if they both have something to say for themselves, as in the Metamorphosi chair, which is half art nouveau and half modern.

He predicts that the home will always be the same. No technohouse of the future full of monitors, televisions, or strange unfamiliar lights for Raggi; he sees the home as an archaic place, full of intimate personal heirlooms, private scandals mixed in "indecent" combinations. It will also be populated by new "characters" of low-technology content, such as textiles, surfaces, knickknacks, and a "family" of high-technology objects that have miraculous functions, things that have been in the home for years: telephones, faxes, computer

108

109

Piesse, 1989
Wood, glass, and steel bathroom organizers.
Manufacturer: Fontana Arte

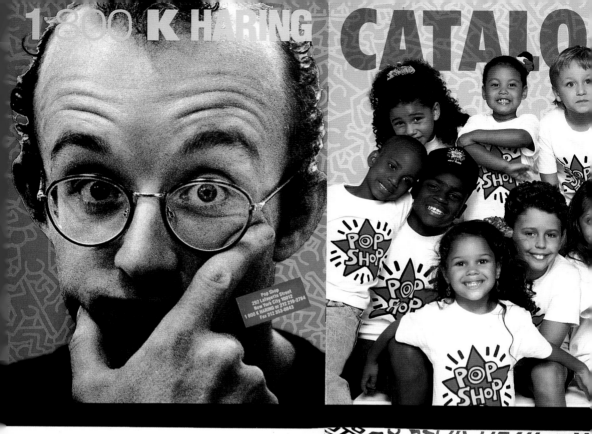

1-800 K HARING CATALO

Pop Shop
292 Lafayette Street
New York City 10012
1 800 K HARING # 212 219-2784
Fax 212 353-0843

"The Pop Shop makes my work accessible. It's about participation on a big level."

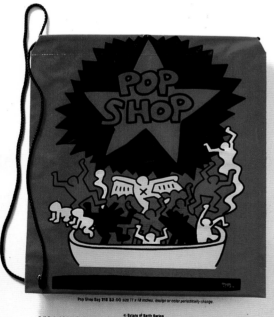

Pop Shop Bag 218 $2.00 size 11 x 16 inches. design or color periodically change.

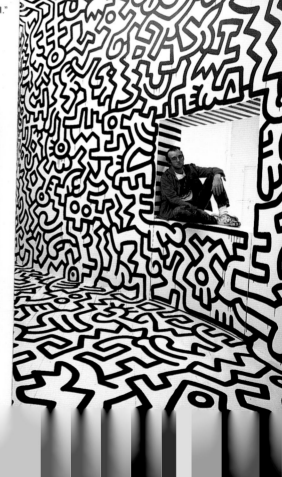

© Estate of Keith Haring
Keith Haring left the bulk of his estate including the Pop Shop to the Keith Haring Foundation, Inc., a not for profit organization.
Design and concept by Dan Friedman with new photography by Mark Contratto.
Portraits of Keith Haring by Tseng Kwong Chi and Maria Mulas
Special thanks to all participants.

Quotations by Keith Haring are from the following sources:
John Gruen, Keith Haring: The Authorized Biography, Prentice Hall Press, 1991
Keith Haring, Flash Art, March 1984
Keith Haring, Art in Transit, Harmony Books, 1984
David Sheff, "Keith Haring," Rolling Stone, August 10, 1989
Leo van Damme, "Keith Haring," Artefactum, Antwerpen, November 1984

All small patches $2.50

All large patches $5.00

Patches are shown at actual size

"The use of commercial projects has enabled me to reach millions of people whom I would not have reached by remaining an unknown artist. I assumed, after all, that the point of making art was to communicate and contribute to culture."

Keith Haring

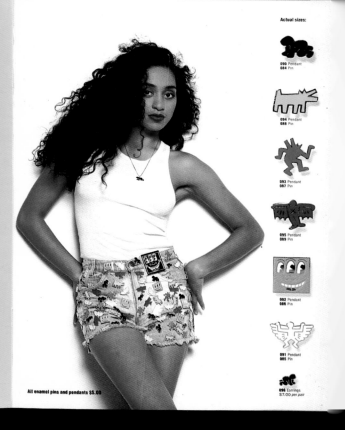

All enamel pins and pendants $5.00

Actual sizes:

090 Pendant
084 Pin

094 Pendant
088 Pin

093 Pendant
087 Pin

095 Pendant
089 Pin

092 Pendant
086 Pin

091 Pendant
085 Pin

096 Earrings
$7.00 per pair

CATALOG, 1991. The cover and representative pages of a mail order catalogue for the Pop Shop, a source of T-shirts and small objects created by Keith Haring and now managed by his estate.

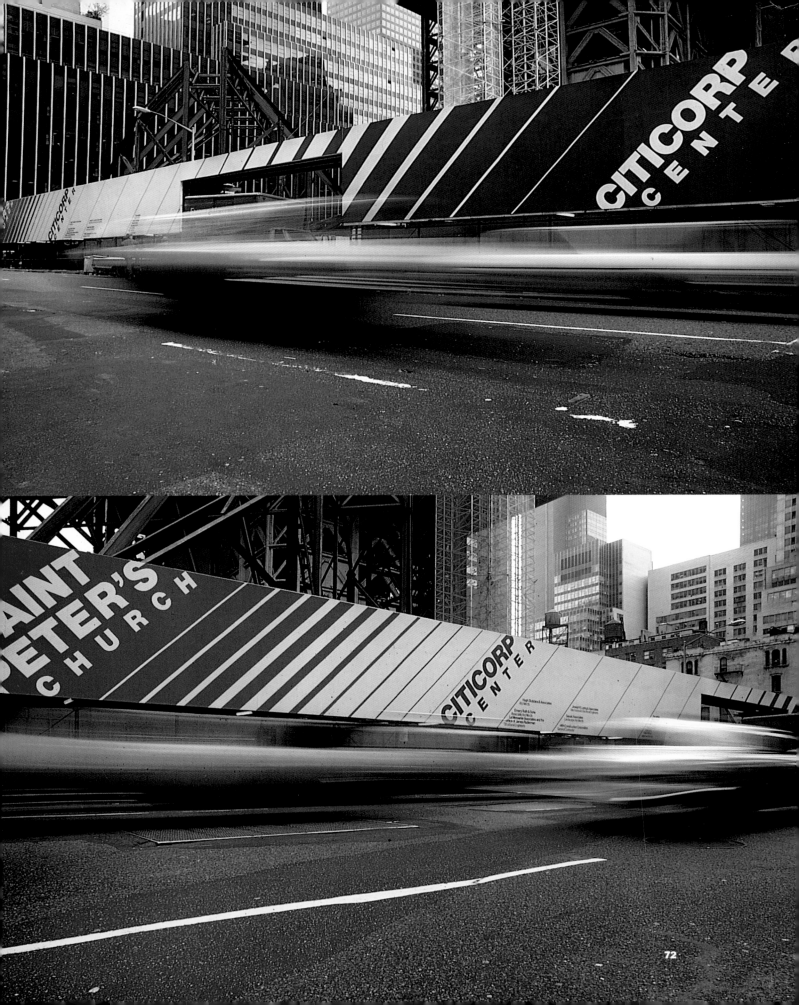

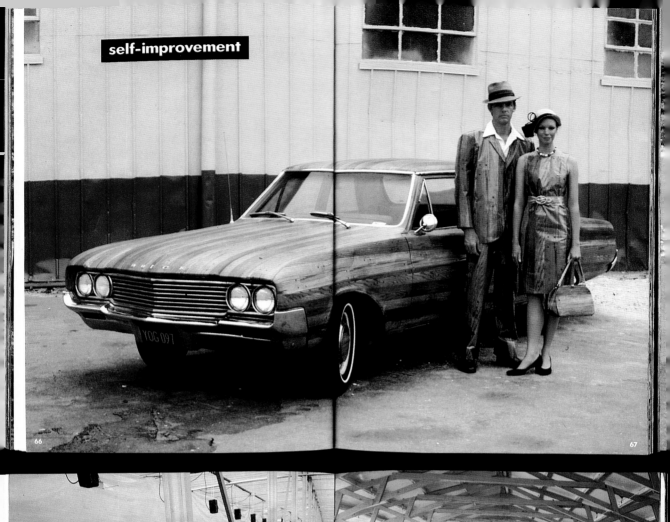

self-improvement

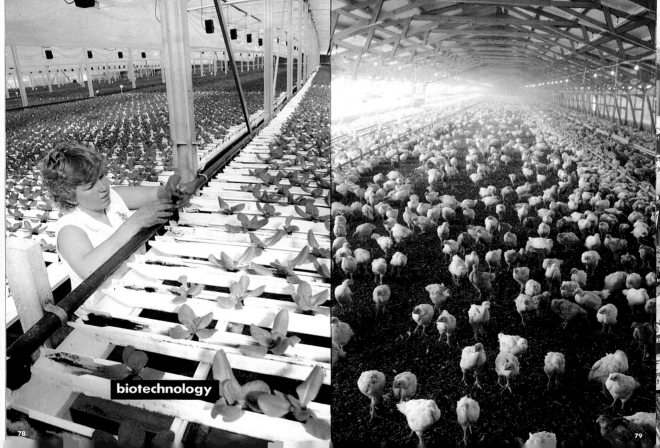

biotechnology

Mental Furniture

In the mythology of early modernism, the form of furniture (and other objects of design) evolved by being *true* to its material, its function, and its method of (mass) production. Only by being reduced to its essential characteristics could the form approach a *moral* integrity. Commitment to this ideal has produced success as well as limitation. "Form follows function" may have had an intellectual logic in relation to early industrial production, but, ironically, modern materials and technology no longer call for this sort of purism. In fact, the appropriateness of this purism to industrial production may have been suspect from the very beginning. And the goal of reducing and simplifying was less a fact than a denial of the richness and complexity actually inherent in the form and meaning of most objects.

In neomodern design, many experiments have attempted to broaden or undermine our former concept of functionalism. Form still follows function, but it also follows fantasy and new mythologies. *Mental furniture* consists of new forms in which functionalism is not the only goal but a vehicle for symbolic meanings beyond those purely involving use. These meanings can be "read" as if they were a subtext. The process of reading relates to my analysis of typography (see page 44), using the opposing criteria of legibility (functionalism) and unpredictability. This critical theory tends to see objects as hybrids, leveling the distinctions between high art and popular culture, abstraction and representation, pragmatism and symbolism, expressionism and conceptualism. For good or bad, hybrids have become a paradigm of modern life. There are many examples: former Communist rulers who consult media experts; processed food that has been fortified; macho men who are also vulnerable; cultural events that are tax deductible; long skirts in transparent fabric; contemporary buildings that look classical; angry mobs with religious convictions; *Star Trek* dubbed for French television; synthetic materials made to look natural; mobile homes; deficit spending; plastic glasses; art furniture.

Since the late 1970s I have been engaged in a predominantly European-based philosophical dialogue surrounding furniture. The emphasis of the symbolic over the functional has been a major theme. In Italy, innovation has been facilitated by a heritage of fine craftsmanship; by large business interests that resurged following World War II while they financed a supportive print media; by a network of cottage industries that easily adapt to experimentation; and by designers who tend to be architects and to see furniture as metaphors for their broader ideas. In France, too, design innovation is often presented as an opportunity for business, subsidized by government, and cherished because it is perceived as a contribution to the nation's culture. (Culture needs nourishment: France has roughly one-fifth of the population of the United States, yet its Ministry of Culture spends about twenty-nine times as much per capita as our National Endowment for the Arts.)

LA CHAMBRE DE VINCENT A ARLES, by Vincent van Gogh, 1889. Collection of the Musée d'Orsay in Paris.
AFRICA TABLE, 1987 (opposite). Plywood, plastic laminate, and painted metal, 40 x 110 x 110 cm. Private collection.

Announcing:
SPACE

The new picture
newspaper of the
Institute for
Energy and Vision
To be published
in 1977

Send contributions
and proposals to:
The Institute for
Energy and Vision
P.O. Box 785
Old Chelsea Station
217 West 18th Street
New York, NY
10011

SPACE

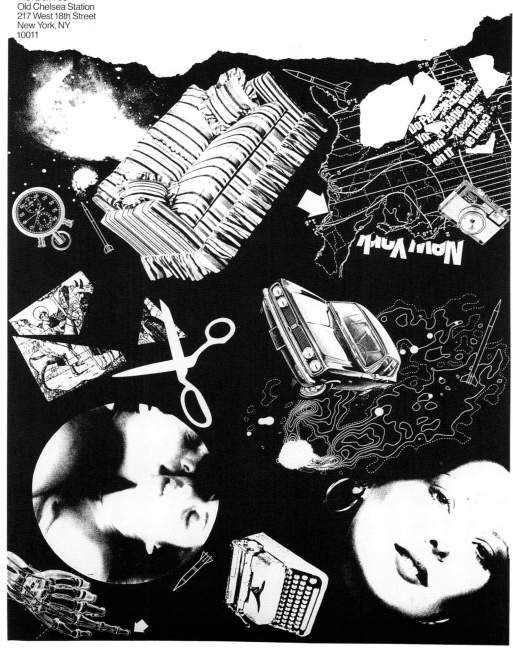

SPACE, 1976. A poster, made with "found" visual elements, promoting the introduction of a picture newspaper.

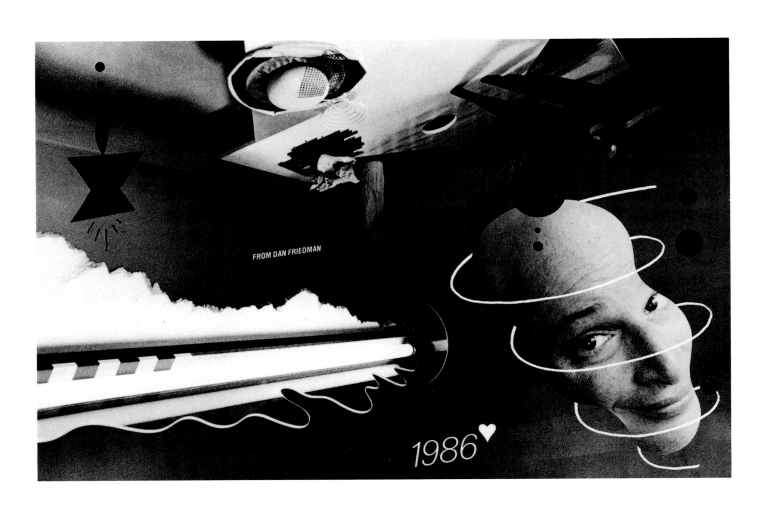

NEW YEAR'S CARD, 1986. An example of the cross-fertilization that often occurs between
my design of printed matter and the design of my own living environment (opposite).

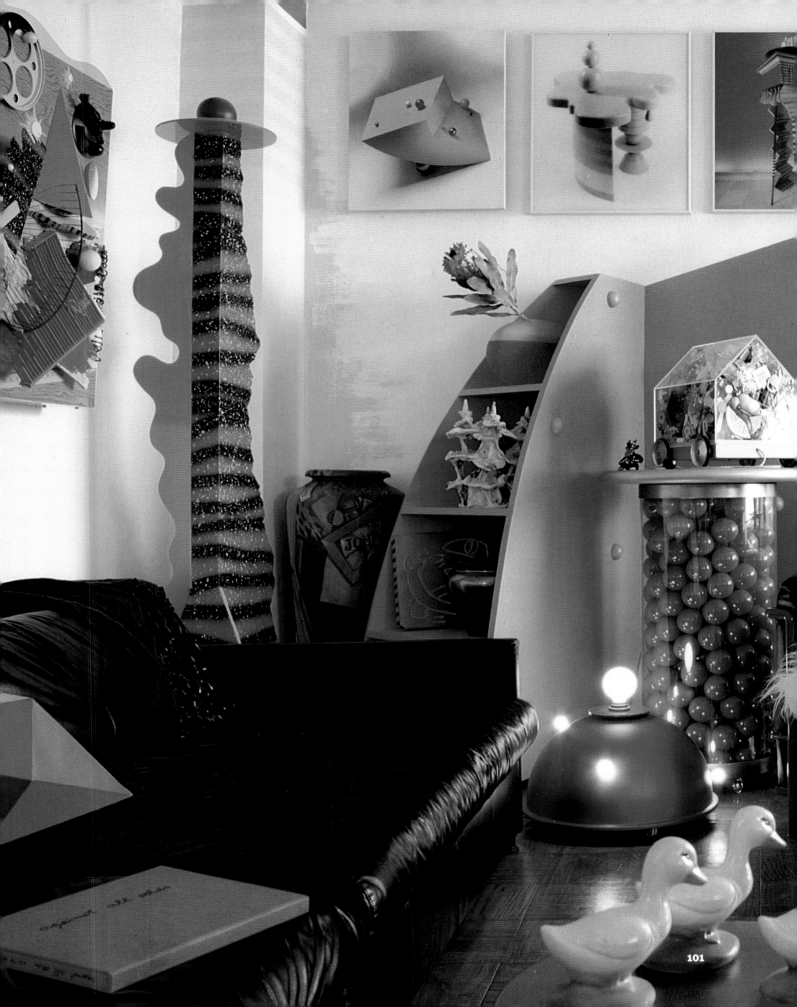

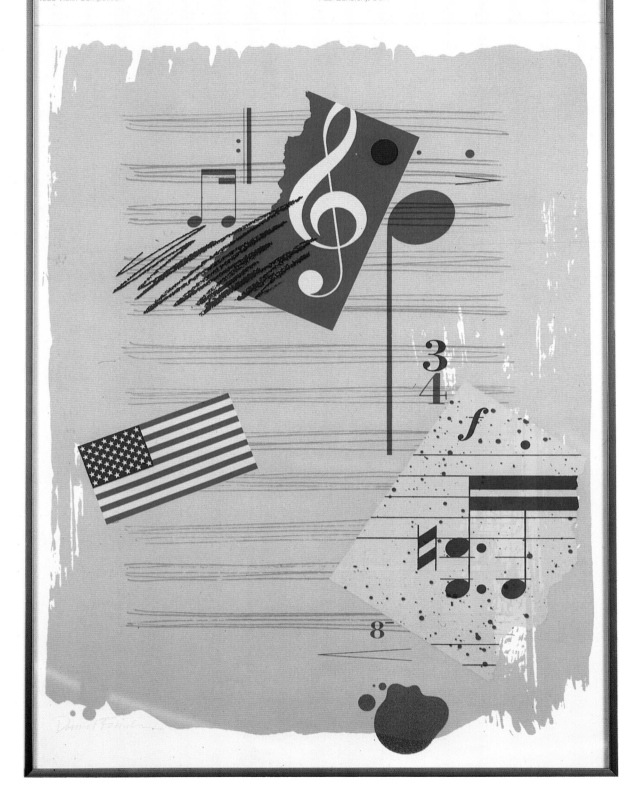

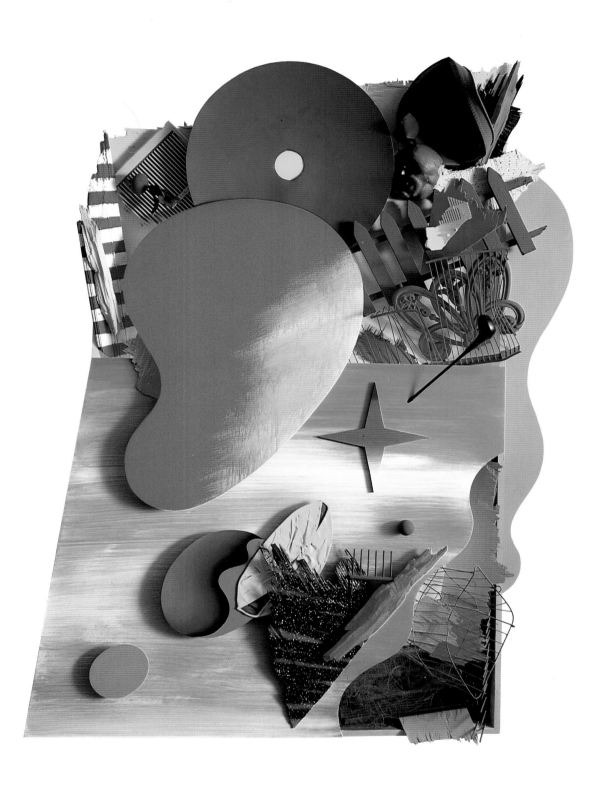

THE ZEN OF GOLF, 1985. An assemblage of painted wood and found objects, 216 x 153 x 38 cm.
Collection of Laurie Mallet in Paris.
THE ROCKEFELLER FOUNDATION, 1980. A silk-screened and engraved certificate (opposite)
for winners in annual competitions for the performance of new American music.
Designed while I was associated with Pentagram.

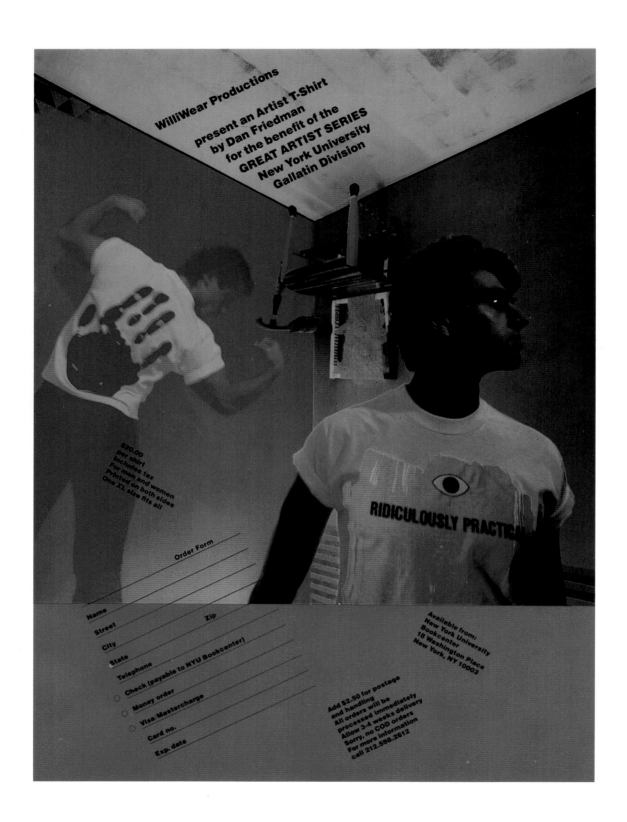

GREAT ARTIST SERIES, 1985. Advertisement for the sale of a T-shirt produced by WilliWear
to benefit a New York University lecture series.

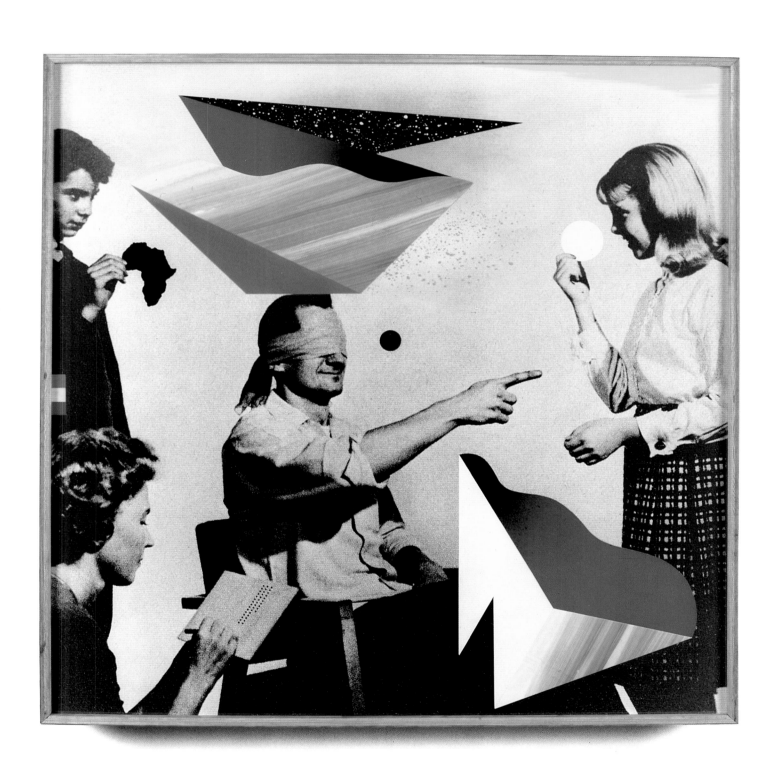

THE BLIND LEADING THE BLIND, 1986. A collage of painted papers and photograph, 90 x 90 cm. Private collection.

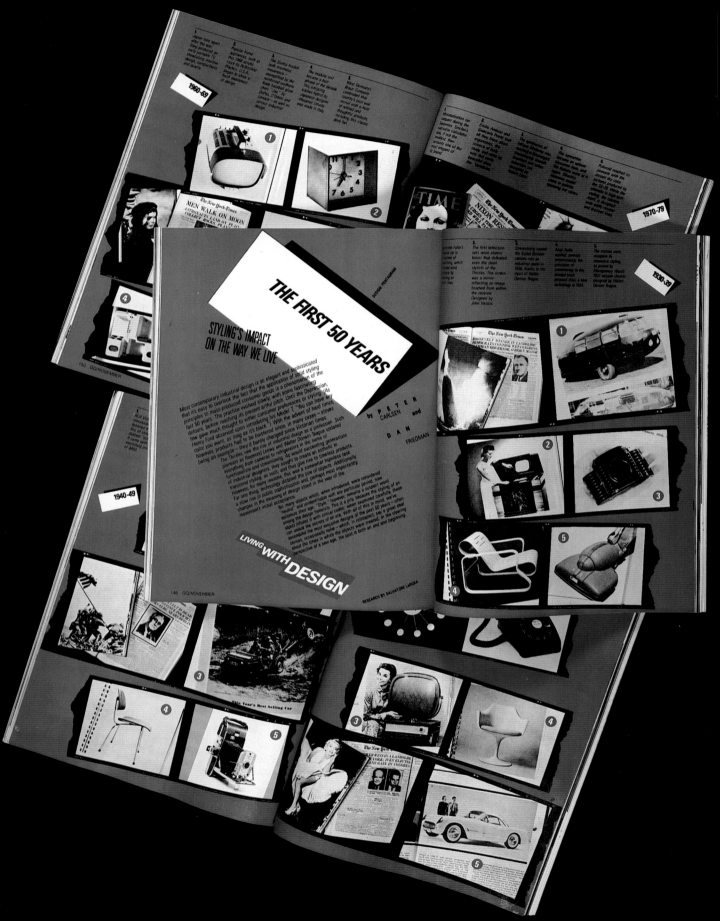

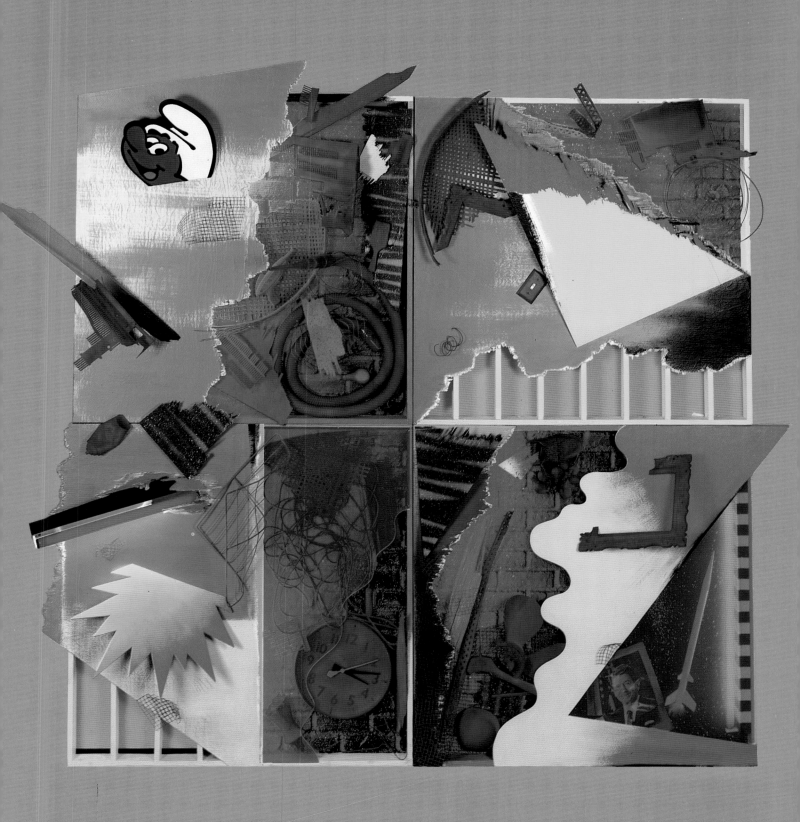

THE WALL, 1985. An assemblage made to appear as an actual wall preserved in a state of explosive fragmentation; made with a painted wooden structure, light fixtures, and various painted found objects, 272 x 256 x 38 cm.
GQ MAGAZINE, 1979. "The First Fifty Years," an article (opposite) about the evolution of style in mid-twentieth-century design. Written in collaboration with Peter Carlsen and designed while I was associated with Pentagram.

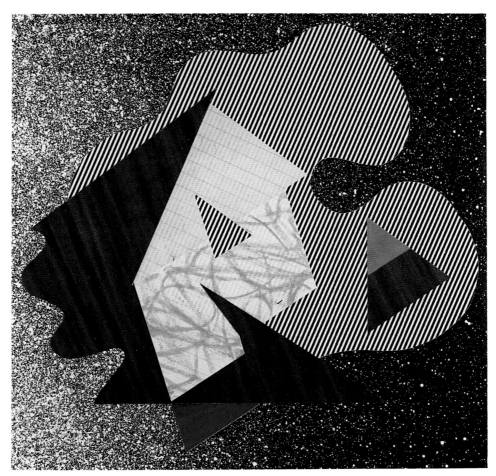

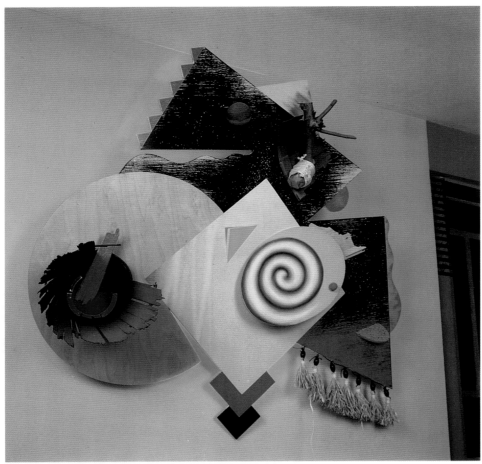

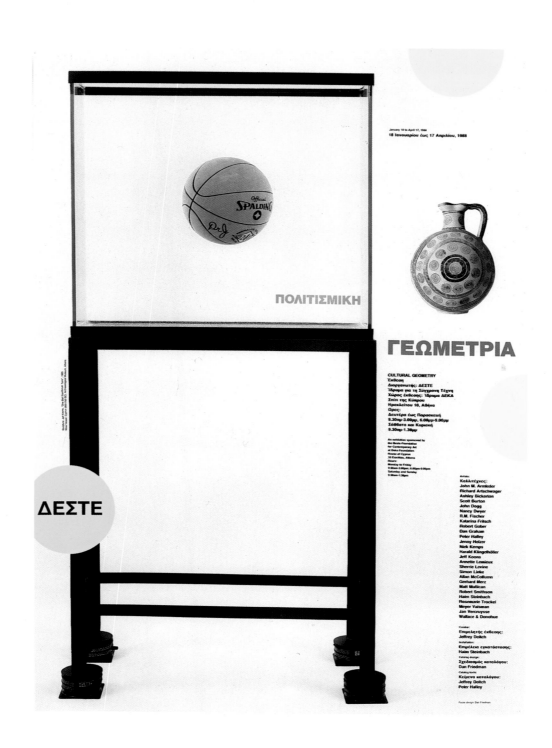

CULTURAL GEOMETRY, 1988. Exhibition poster for the Deste Foundation for Contemporary Art;
juxtaposes photograph of sculpture by Jeff Koons with classical Cypriot wine vessel.
UNTITLED, 1971. A collage of various papers (opposite above). Collection of April Greiman in Los Angeles.
TORNADO FETISH, 1985. An assemblage (opposite below) of painted wood, raffia, and found objects, 153 x 140 x 46 cm.

ΠΟΛΙΤΙΣΜΙΚΗ ΓΕΩΜΕΤΡΙΑ

Cultural Geometry

CULTURAL GEOMETRY, 1988. The cover photograph of a Texas family and their various vehicles is used as a symbol for a growing, international, commodity-based culture. The exhibition catalogue text by Jeffrey Deitch (opposite) analyzes the work of contemporary artists who are mining a debased modernism which is characterized by an exhausted, sanitized formalism found throughout the world (International Style). The new art also uses geometric formulations, but emphasizes how those forms can be seen as codifications of cultural meaning, especially when juxtaposed with examples from modern and ancient Greece.

indrani

2

Classical
Dance
of
India

1 **Spring Festival
of Dance**

2 **Indrani**
Saturday, April 14
8:00 PM

 **at the Jewish
Community
Center**

3 **New Haven
Dance Ensemble**
8:00 PM, May 19
to be announced

Presented by
the New Haven
Dance Theater
with assistance of
the Connecticut
Commission on
the Arts

For tickets call
777 5595 or write
New Haven
Dance Theater
154 McKinley Ave
New Haven, Ct.
06515

Single tickets $3.00
Student rush $2.00

Daniel Friedman

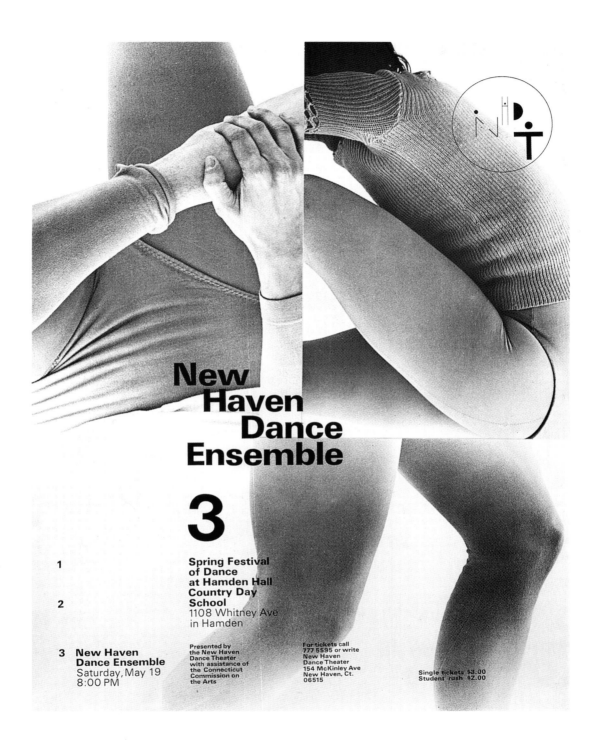

New
Haven
Dance
Ensemble

3

1

2

Spring Festival
of Dance
at Hamden Hall
Country Day
School
1108 Whitney Ave
in Hamden

3 New Haven
Dance Ensemble
Saturday, May 19
8:00 PM

Presented by
the New Haven
Dance Theater
with assistance of
the Connecticut
Commission on
the Arts

For tickets call
777 5595 or write
New Haven
Dance Theater
154 McKinley Ave
New Haven, Ct.
06515

Single tickets $3.00
Student rush $2.00

NEW HAVEN DANCE THEATER, 1971. Two of a series of three posters that incorporated the NHDT symbol with graphic abstractions for three different dance recitals.

cation if they are associated with a particular language, time frame, location, or culture that is too narrow for the larger context in which the idioms may have to function. The potential for mixing abstract and vernacular has been impressively explored in media such as music, art, film, and television. In the future, designers of new visual forms will also find it more difficult to choose one idiom to the complete exclusion of the other.

I have designed more than forty logos and symbols. The design for Citibank is part of the most complex visual program with which I have been involved (see page 136). For reasons explained in the previous section, I now look upon that project with a mixture of pride and cynicism. It has become apparent that these visual identities are often a kind of packaging, that they reflect a preoccupation with the way things look more than with what they mean. Many identities become predictable and indistinguishable as companies change management, diversify, and expand internationally. There are numerous examples of distinguished corporate images (those of IBM and Mobil, for example) that gradually deteriorated in quality as the initial visionary designer/entrepreneur relationship dissolved. Some logos (Prudential, NASA) that were "modernized" in the past have nostalgically returned to their earlier, less abstract idioms. There is clear evidence that the business of creating corporate images is in crisis as a result of shallow formulas and the changing nature of corporations. Graphic identities need no longer depend on the static, monolithic systems that once seemed necessary. For complex projects, managing visual diversity is now a greater challenge than imposing a narrow-minded consistency. The potential for innovation and experimentation in the future will likely be greater for designers working with smaller, more localized organizations and with the possibilities of the new electronic media.

Examples (above) of vernacular and abstract symbols.
Street Shoes, a symbol for a shoe store, is appropriated from a vernacular street sign.
The more abstract symbol is for *Gallimaufry,* a shop for modern household objects.
LUDICK, 1990 (opposite). A logo created for Paul Ludick, New York City furniture maker.

123

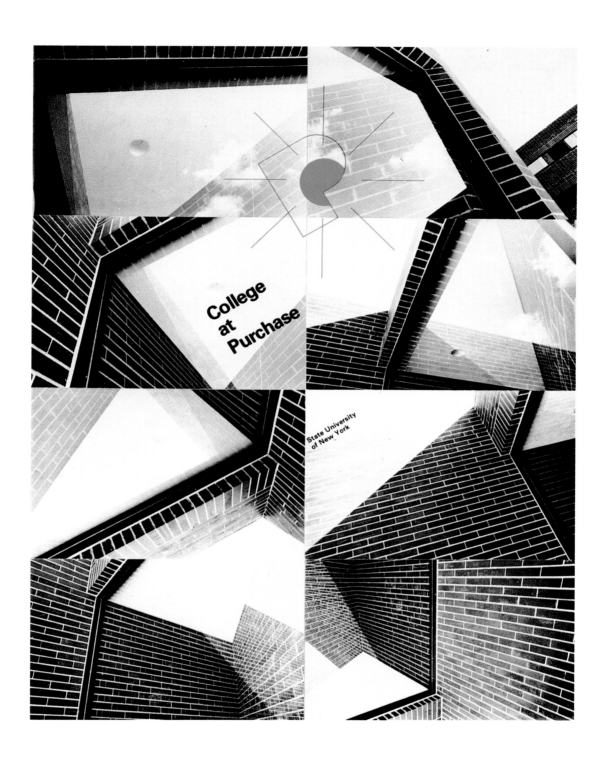

STATE UNIVERSITY OF NEW YORK, 1973. A symbolic abstraction for SUNY in Purchase (opposite),
and as used on the cover of an admissions catalogue with a collage of photographic abstractions of university buildings.

The AGI Student
Symposium I

AGI
1 9 7 9
U S A
S U N Y

ALLIANCE GRAPHIQUE INTERNATIONALE, 1979. The cover of a brochure that uses a symbol
created especially for a symposium sponsored by AGI at the State University of New York.
Designed while I was associated with Pentagram.

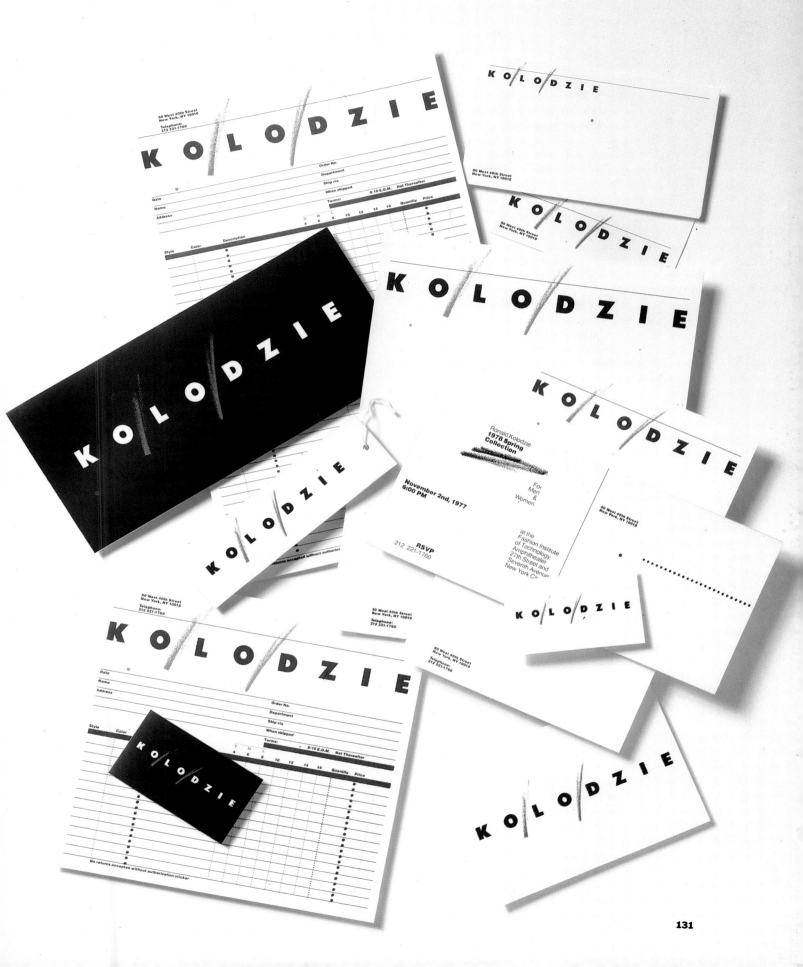

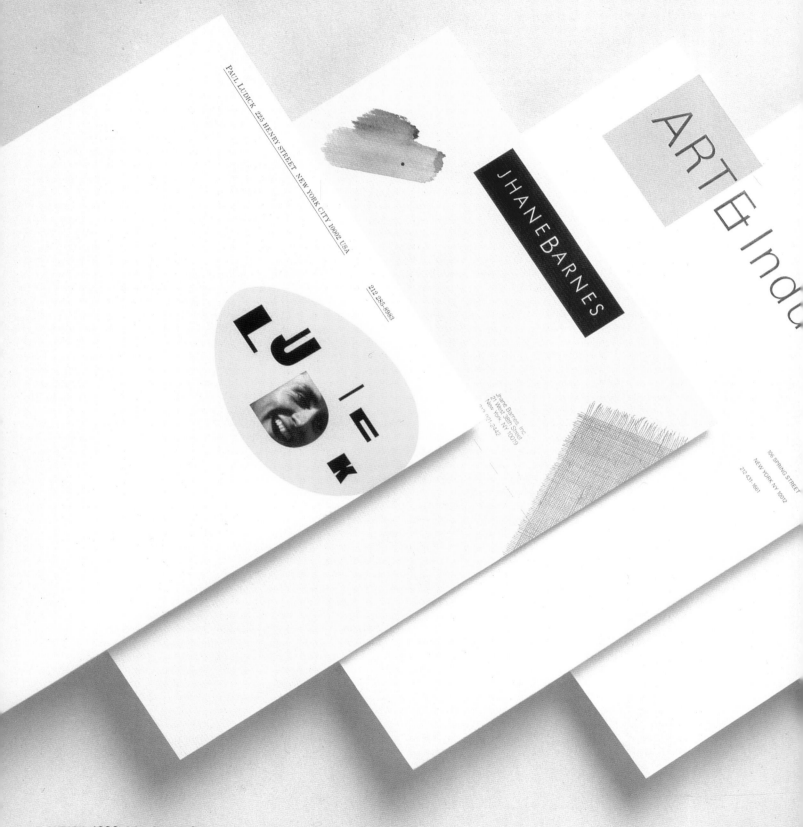

LUDICK, 1990. A furniture maker.
JHANE BARNES, 1979. A fabric and fashion designer.
ART ET INDUSTRIE, 1988. A gallery for experimental furniture.
THE INTERNATIONAL AMERICAN MUSIC COMPETITIONS, 1980. An enterprise sponsored by the Rockefeller Foundation.
GOOGOLPLEX, 1982. A video production service.
GALLIMAUFRY, 1987. A shop for modern household objects.

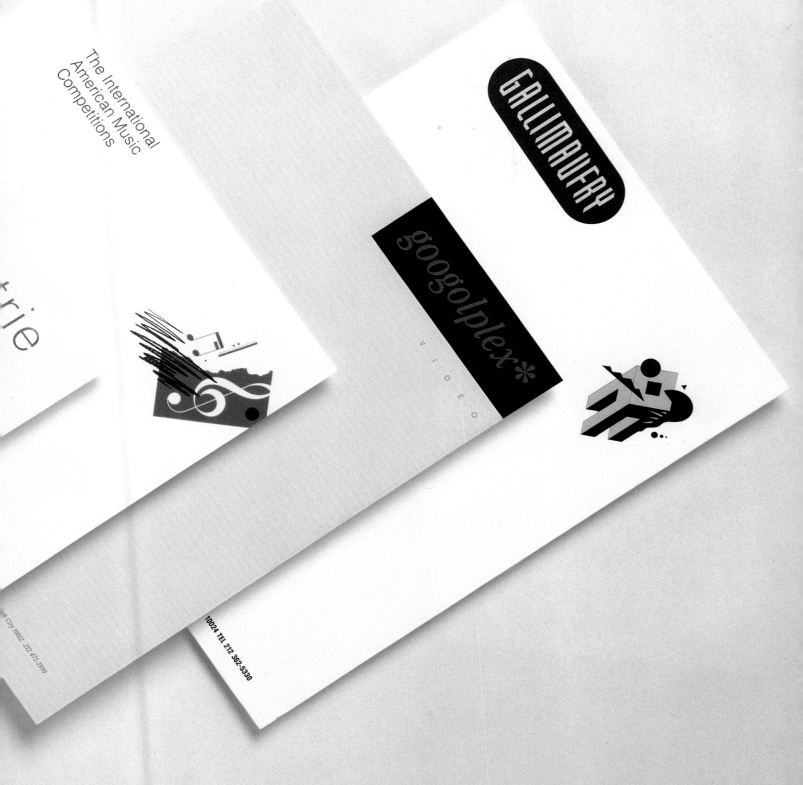

Visual identities do not rely only on logos and symbols. As these letterheads show, typography, color, and additional elements contribute to the overall impression. See also the additional examples applied to various business cards, on the following pages.

Manuel Yanez

Telephone: 212 691-4574

Richard Horn
30 Cornelia Street
New York City 100__ __14
212 675-0421

PAUL LUDICK
225 HENRY STREET
NEW YORK CITY 10002
212 285-8983

Go

Pinky & Dianne
PRIVATE LABEL

Pinky & Dianne Ltd.
37 West 57th Street
Suite 701
New York, NY
10019

Pinky & Dianne (Far __)
27A Cameron Road, 3rd __
Tung Fai Building
Kowloon, Hong Kong
Telephone: 3-675194-6
Telex: 36841 PNDHK HX
Cable address: Privatelab

Telephone: 212 935-4770
Telex: 425413 PNDNY
Cable address: Pripidi

Karen
Lane
Associates,
Inc.

Jeffre
Deit

Thomas Walther

451 Broome Street
New York, NY 10013
212 431.9241

Niebuhrstrasse 2
1000 Berlin 12
030.881.1541

googolplex*

VIDEO

Kate Carmel

1 0000000000
0000000000
0000000000
0000000000

googolplex inc. 77 Bleeker Street New York City 10012 212 475-3990

* 0000000000000000
A mathematical whimsey identifying the last real number 000
before infinity – 1 followed by a billion zeroes. 0000000000

Juan DuBose

Music/Tapes

212 925-7977

The Communications Service
of the City of New York

One Centre Street
New York, NY 10007

A member of:
National Public Radio
Public Broadcasting Service

 AM83 FM94 TV31

PHOTOGRAPHER

212
477-1908

ge Alfaro

K|O|L/O|D|Z|I|E

Alfredo
Oscars Son

35-15 Junction Blvd.
Corona, NY 11368
458-3333

Rick Kaufmann

106 SPRING STREET
NEW YORK NY 10012

212 431-1661

ART⊟Industrie

CITIBANK◄●►

Citibank, N.A.
New York

Walter B. Wriston
Chairman

y

h

CHICKEN LITTLE'S

STREET
SHOES
↑

1108 Polk Street
San Francisco, CA
94109

415 441-3148

The Museum of Modern Retail

574 South Coast Hwy
Laguna Beach, CA
92651

714 494-9810

Lexington Avenue New York City

Ken Probst
Photographer
74 Jane Street
New York, NY
10014

212 929-2031

JHANEBARNES

Jhane Barnes, Inc.
21 West 38th Street
New York, NY 10019

212 921-2442

GALLIMAUFRY

444 COLUMBUS AVENUE NEW YORK NY 10024 TEL 212 362-5330

It is not the concept of modernism but the
assimilation of modern style by the corporation that has become so
internationally accepted. The emphasis of style over substance
is one factor that has pushed the design of corporate
identity into bland predictability.

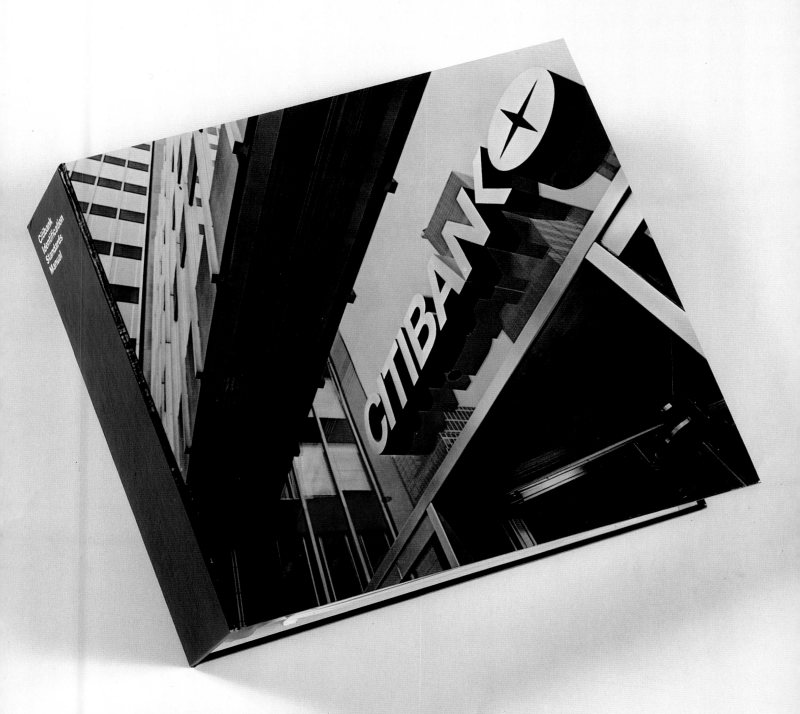

CITIBANK, 1975. The logo and symbol (opposite) were created when the name was legally changed from First National City Bank. They were designed while I was associated with Anspach Grossman Portugal, Inc. *The Citibank Identification Standards Manual* (above and on pages 140-141) gave directions to Citibank offices throughout the world so that all forms, stationery, signage, and promotional materials would eventually appear consistent with the company standard.
My sketches (overleaf) exhibited at Anspach Grossman Portugal, Inc., show an evolution of possibilities from the original symbol for First National City Bank (upper left) to the final solution (lower right).

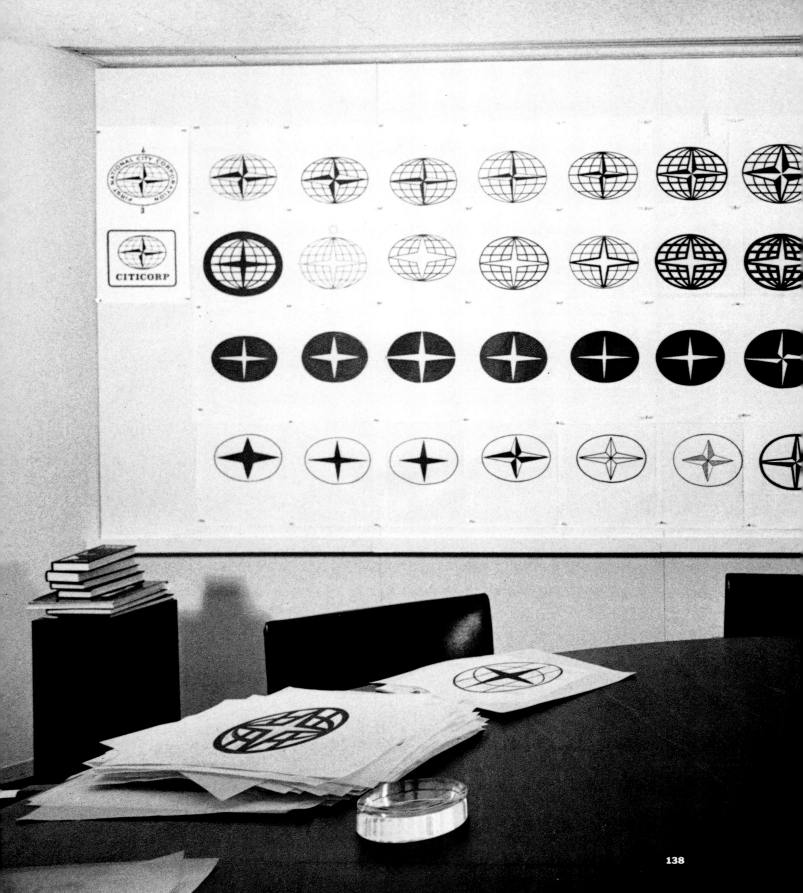

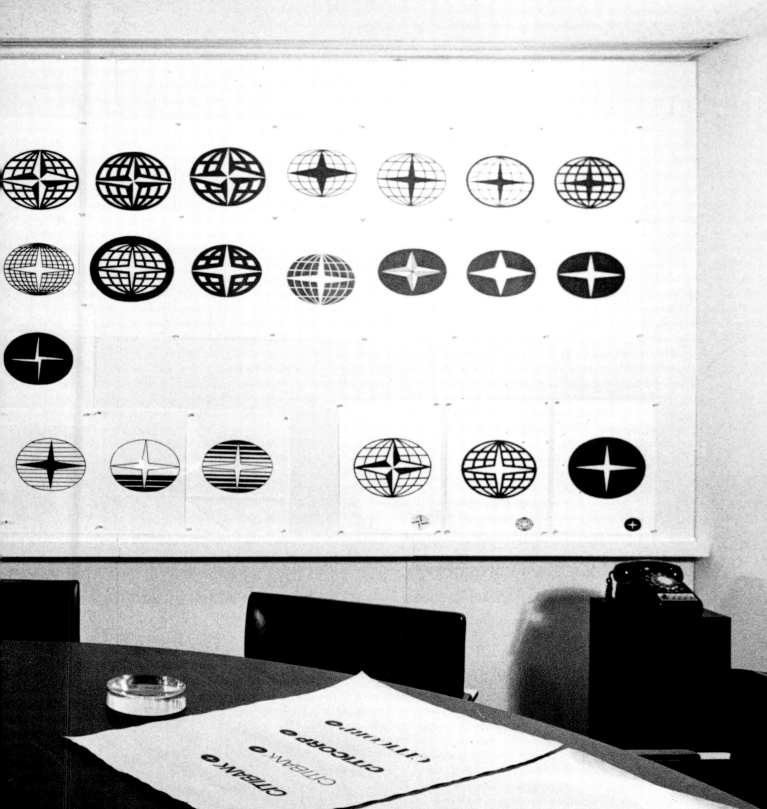

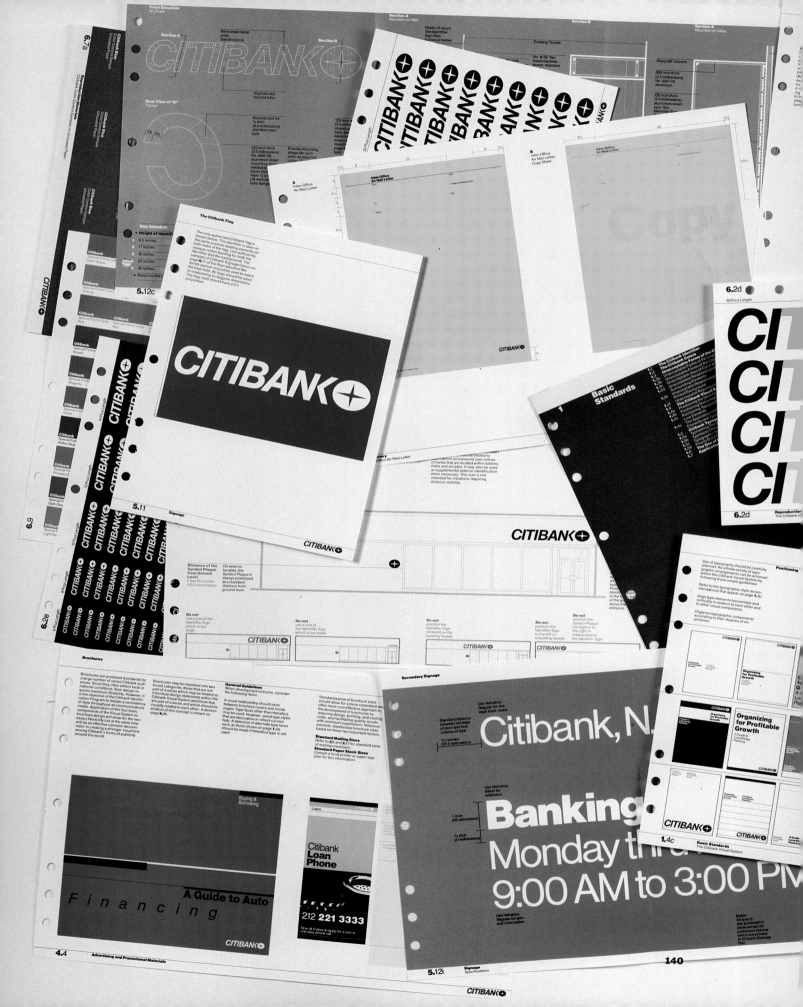

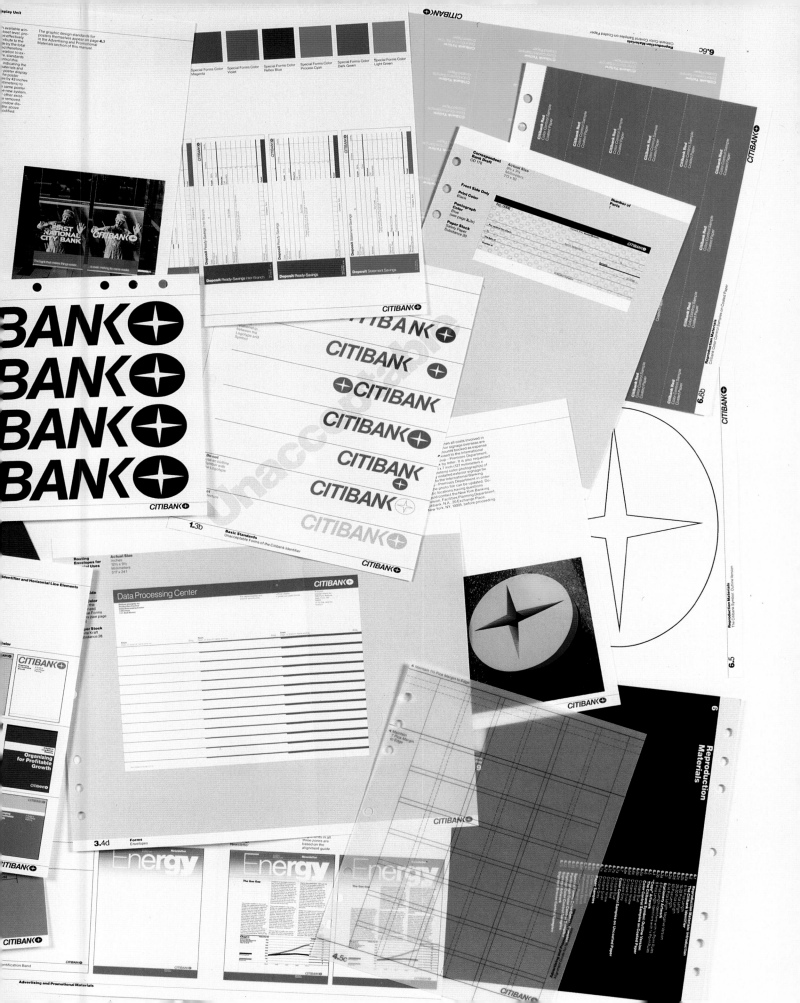

Hip-Hop Modernism

by Jeffrey Deitch

I remember staring at my Citibank business card for hours. I would prop it up on my desk and study it while I talked on the telephone. I was drawn into it and repelled by it at the same time. It was crisp and official in its corporate modernism, but it was somehow disturbing in its lack of expected balance. Unlike the standard design idioms one had become so accustomed to, the forms did not settle into equilibrium. The lines of type did not just lie there in corporate complacency, but threatened to jump right off the surface.

It is ironic that I began to know Dan Friedman, my future collaborator, through this irritating little business card that I was always taking out of my pocket and trying to decipher. We separately became involved with Citibank in the 1970s, Dan as a member of the team responsible for the radical redesign of their corporate graphic image, and I as one of the founders of their controversial art advisory department. It was only several years after I joined Citibank that I met Dan in person. It should not have been a surprise that he looked just like his designs. The clean, modern form of his perfectly shaped bald head evoked the memory of Bauhaus heroes like Johannes Itten and Oskar Schlemmer. But, like my Citibank business card, Dan's image was somehow deliberately "off" and aggressively out of balance. Dan used to remark to me how his appearance, which should have been perfectly benign, often seemed to provoke people. I witnessed this once in person when the critic Gary Indiana inexplicably erupted at Dan, railing on about his shaved head at a previously peaceful dinner party we were attending on an idyllic Greek island. I later realized that this reaction to Dan himself was very similar to the reaction I frequently observed when I pulled out the Citibank card.

I joined Citibank in 1979, shortly after the new corporate identification program had been introduced. The company, in the midst of an aggressive expansion, was pioneering new approaches to the technology of banking, and the new design seemed to embody this new corporate culture exceptionally well. Some of the older, more conservative managers had difficulty with the new graphic design (just as they did with the newly aggressive culture of the company). I remember how a number of my older colleagues just couldn't bring themselves

Post HUMAN

POST HUMAN, 1992. This book was conceived to accompany a contemporary art exhibition traveling in Europe in 1992 and 1993. The text by Jeffrey Deitch describes how new medical and electronic technologies, as well as changing body and mind-altering sensibilities, are providing new opportunities for individuals to reinvent themselves and also new inspiration for artists in representing the human figure. The book continues a method of understanding the images of new art within the context of images of our emerging culture. Examples of the design of the inside of the book are shown on the following pages.

Human evolution may be entering a new phase that Charles Darwin never would have envisioned. The potential of genetic reconstitution may be quickly propelling us beyond Darwinian natural evolution and into a bold realm of artificial evolution. Our society will soon have access to the biotechnology that will allow us to make direct choices about how we want our species to further evolve. This new techno-evolutionary phase will bring us far beyond eugenics. Our children's generation could very will be the last generation of "pure" humans.

This new sense of one's power to control and, if desired, reconstruct one's body has quickly developed a broad acceptance, but there is still a significant segment of society that is deeply disturbed by its implications. The bitter debate over abortion rights is an example of how explosive the controversy over the limits of "natural" life will become. The battle over the abortion issue and the outcry over euthanasia and the right to choose suicide may be just the beginning of an enormous social conflict over one's freedom to use the new biotechnology to take greater control over one's body and to enhance the course of one's life.

The issue of using genetic engineering to "improve" the fetus will potentially become much more highly charged than the controversy over abortion. It may not be an exaggeration to say that it will become the most difficult moral and social issue that the human species has ever faced. Genetic engineering is not just another life-enhancing technology like aviation or telecommunications. Its continued development and application may force us to redefine the parameters of life.

Our consciousness of the self will have to undergo a profound change as we continue to embrace the transforming advances in biological and communications technologies. A new construction of the self will inevitably take hold as ever more powerful body-altering techniques become commonplace. As radical plastic surgery, computer-chip brain implants, and gene-splicing become routine, the former structure of self will no longer correspond to the

Virtual-sex

programs featuring

every simulated sound

and sensation are not only likely

to be better in many ways than

the real thing, for future generations

they may *become* the real thing.